IMAGES
of America

AROUND
NORTH COLLINS

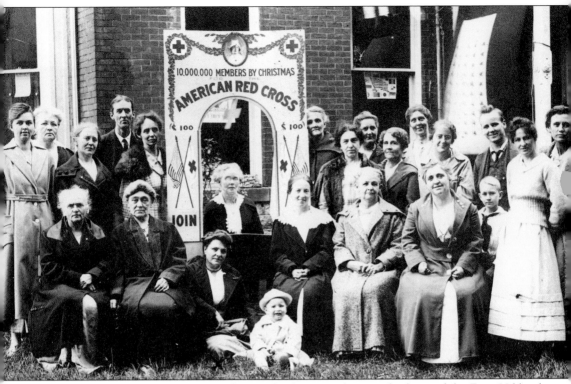

This picture of early American Red Cross fundraising taken on the lawn of the Enos Hibbard home in North Collins is a typical image of the southern Erie County area. The people seem to have been born with a willingness to help each other in times of need. Neighbors helped neighbors by putting up early settlers' cabins, harvesting crops, educating children, and in any emergency, from snowstorms to floods.

IMAGES
of America

AROUND
NORTH COLLINS

Georgianne Bowman

ARCADIA
PUBLISHING

Published by Arcadia Publishing
Charleston, South Carolina

Printed in the United States of America

Library of Congress Catalog Card Number: 2002108539

For all general information contact Arcadia Publishing at:
Telephone 843-853-2070
Fax 843-853-0044
E-mail sales@arcadiapublishing.com
For customer service and orders:
Toll-Free 1-888-313-2665

Visit us on the Internet at www.arcadiapublishing.com

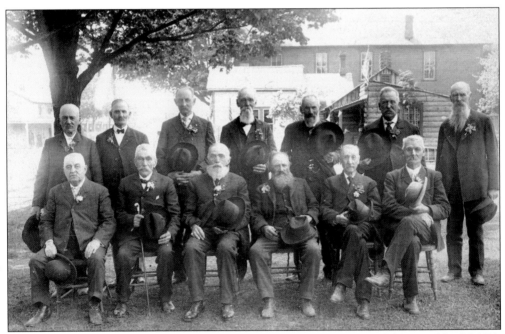

The remaining members of the S.C. Noyes Post No. 220, Grand Army of the Republic (GAR), are shown beside their cabin meetinghouse on Main Street in North Collins. The photograph demonstrates the continuing patriotism that is so prevalent in the southern Erie County area. The picture was taken c. 1900, by which time these Civil War veterans were aging but still turning out regularly for Memorial Day observance. Young men from this area continue to be well represented in the military services.

CONTENTS

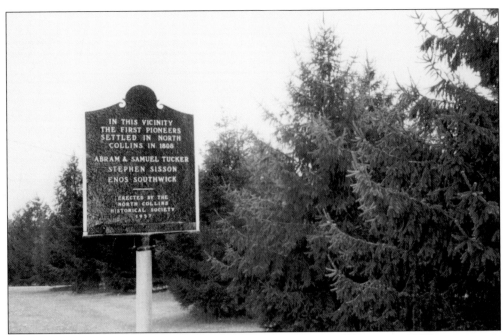

A historical marker was erected by the North Collins Historical Society in 1957 at the north edge of the Blidy property (Starpoint) on Route 62 just south of Milestrip Road. It marks the vicinity of the earliest settlement in North Collins, c. 1808, by the Abram and Samuel Tucker, Stephen Sisson, and Enos Southwick families. It denotes the beginning of settlement and marks the beginning of this pictorial history.

*This book is dedicated to all area residents and historians,
too numerous to recognize individually, who so graciously shared
their photographs, memories, and documentation. It is especially
dedicated to my predecessors, Ethelyn Weller and Grace Korthals,
the first and second town of North Collins historians.
Without their collections, this book would not have been possible.*

INTRODUCTION

Southern Erie County has traditionally been known as an agricultural area. The original settlers provided their own food, whether it had been hunted, fished, or grown on small farms cleared from virgin forest. Simple cane sugar, taken for granted today, was rarely available. Sweeteners were "tree sweetnin" (maple syrup or sugar), "bee sweetnin" (honey), or molasses. Their way of life was much more basic than today, and their log homes often had no glass for windows. Sometimes, a large stump was left in place to serve as a table for the cabin built around it.

By the 1830s, clapboard homes began to appear in the hamlets that had sprung up. A springhouse (a small house built over a cold, fresh spring) was frequently used for short-term refrigeration, but most foods still had to be smoked, pickled, salted, dried, or preserved in some form of alcohol for long-term storage. From the mid- to late 1800s, home canning became popular and is frequently seen even today in this area.

The town of North Collins, which celebrated its sesquicentennial in 2002, had six hamlets—Kerr's Corners (now the village of North Collins), Langford, New Oregon, Marshfield, Lawton's Station (now Lawtons), and Shirley. Shirley was once the center of town, but the population shifted to the village of North Collins after the railroad came through and the depot was built at Kerr's Corners.

Other hamlets in the area included Taylor's Hollow (once a post office for the town of Angola, now the borderline between North Collins and Collins), Clarksburg (now part of the town of Eden), Pontiac (now part of the town of Evans), Collins (from which North Collins separated in 1852), Collins Center, Woodward's Hollow (now Wyandale, part of the town of Collins), Versailles, Brant, Farnham Station (now the village of Farnham), and Angola.

As the area became more settled, larger dairy farms appeared. By the mid-1800s, cheese factories dotted the towns since there was not yet refrigeration and transportation was limited to nearby areas.

As the population increased, vegetable and fruit farms proliferated among the dairy farms to provide fresh produce for the hamlets. By the late 1800s, canning factories had been built in the area, providing employment for the waves of immigrants arriving in the United States from Europe. Basket factories began somewhat before canning factories by providing baskets for cheese wheels (about 50 pounds per wheel) and fresh produce. When the railroad came through the area, produce could be shipped to further markets.

Education progressed from a handful of neighboring children in a cabin being taught the basics of reading, writing, and arithmetic by the literate homeowner in exchange for various goods, to one-room schoolhouses supported by "public monies" as well as small local tax levies. Children had to find their own way to these early schools, frequently by walking. When centralized schools began c. 1950, education included high school and brought district school taxes plus state support. The era of the school bus had arrived.

In 1901, the Pan American Exposition in Buffalo provided many with their first glimpse of electricity—on a grand scale with thousands of electric bulbs lighting the buildings and grounds each night with electricity from Niagara Falls. In just a few years, electricity replaced gas lighting in homes, beginning with those in the hamlets, and then to the outlying farms. In some cases, it arrived at about the same time as the telephone.

Quaker meetinghouses were predominant for the earliest years in this area. New immigrants brought their religious faiths with them, and Congregational, Methodist Episcopal, Baptist, Presbyterian, Roman Catholic, and other churches began organizing.

Newspaper accounts reveal that the residents of the area liked to travel. One resident was said

to have bicycled "all in one day" from Wyandale to Lake Erie and back home again. Although the local hamlet-to-hamlet horse-drawn buggy visits to relatives (often overnight visits) predominated, there was ample evidence of visits or moves to "the West" to see relatives or promote business ventures, and to areas of the South, including New Orleans for the World's Fair.

The farmers were proud of their stock and produce. Registered stock was common from the late 1800s, and stock dealers helped them get the bloodlines they wanted in horses (for draft, carriage, and saddle), cattle (dairy and beef), and most kinds of poultry. Newspaper accounts told of livestock ribbons won at the Erie County Fair and the Springville Fair. At least one North Collins resident worked as a jockey for the East Aurora stables and racetrack prior to his marriage, while others in the town owned fast horses.

All types of social and philanthropic organizations thrived. They were affiliated with national organizations such as the American Red Cross and the Women's Relief Corps, which originated during the Civil War. The Masons and the Eastern Star appeared in the late 1800s, as did the International Order of Odd Fellows and the Rebekahs.

The Grand Army of the Republic (GAR) was prominent as well. Most towns and hamlets sent a large percentage of their eligible men to serve in "Mr. Lincoln's Army." Some even went as far as central New York to enlist in order to serve under General McClellan. When the veterans came home, they formed chapters of the GAR to honor their fallen comrades. The GAR was responsible for the first observances of Decoration Day (now known as Memorial Day).

The Quaker residents, long known as abolitionists whose beliefs prohibited them from serving in a war, were often part of the Underground Railroad through this area to help slaves cross into Canada. Quakers were somewhat radical in their beliefs for the time. They also embraced women owning property and voting in their own separate meeting. Susan B. Anthony came to North Collins to speak at the North Collins Hicksite Quaker Meeting House in September 1857 before a convention of the Friends of Human Progress, an organization with large numbers of Quaker members.

Both spiritualism in the late 1800s and temperance movements through Prohibition were prominent as well. Many gravestones bear the spiritualist belief with words like "passed to the other side" preceding the date of death. Poems by Emma Train, which appeared almost weekly in the local newspaper, often noted spiritualist ideas.

Politics were important, and local newspapers carried accounts of local, county, state, national, and international political developments. North Collins had its own Political Equality Club beginning c. 1890. It was made up largely of women, even though women's suffrage had not yet arrived.

Today, the region has become a mixed economy, with the dairy industry no longer so prevalent. Truck farms have grown large and produce a wide variety of fruits and vegetables, which are wholesaled to markets in the Buffalo area and south. Small businesses abound, some still in their original locations as cottage industries.

Although the area has seen a rise in new construction with new families, the town of North Collins still counts many of the original settlers' families in its population. At least one dairy farm has been handed down through the generations during the whole period and is still operated by that family.

As in other areas, the senior citizen population has grown considerably. Many remain very active, with some still running the businesses they began many years earlier. Senior citizens clubs in the towns are well attended and active. Other organizations, such as church groups, Boy Scouts, Girl Scouts, volunteer fire companies, the North Collins Emergency Squad, political parties, historical societies, veterans' organizations, Rotary International, the Greater North Collins Chamber of Commerce, and many other smaller groups also are active and strong in the community.

The area is once again slowly growing, and residents enjoy life in these quiet towns. Clearly, in North Collins, the sense of belonging in a small community is priceless. As the North Collins sesquicentennial logo says, the area is "Looking to the Future, Rooted in the Past."

One

SHIRLEY

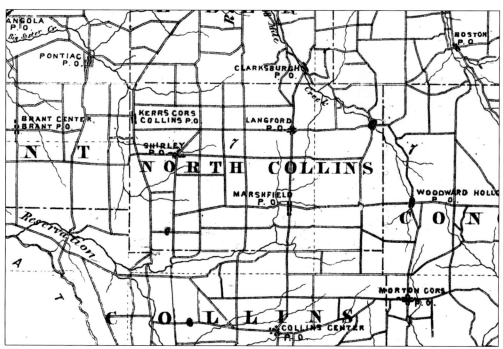

The southern Erie County area experienced a great deal of business and social interaction between hamlets and towns. Note that Collins, Lawtons Station (or Lawton's), and New Oregon are not shown on this map, but dots have been added to indicate their locations.

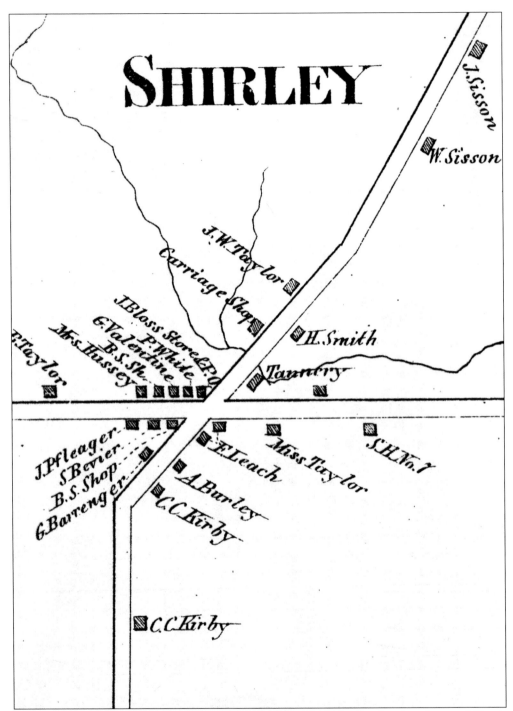

SHIRLEY

The hamlet of Shirley, originally settled by English Quakers, was the first heart of North Collins, until the railroad came through in 1872. Its residents in 1866 included general store owner J. Bloss; blacksmiths Benjamin Smith, J. Pfleagel, and B.C. Taylor; tanner and currier J.W. Taylor; and cheesemaker Michael Johengen. It later included a slaughterhouse, gristmill, and a stagecoach stop, which still stands and is a private home.

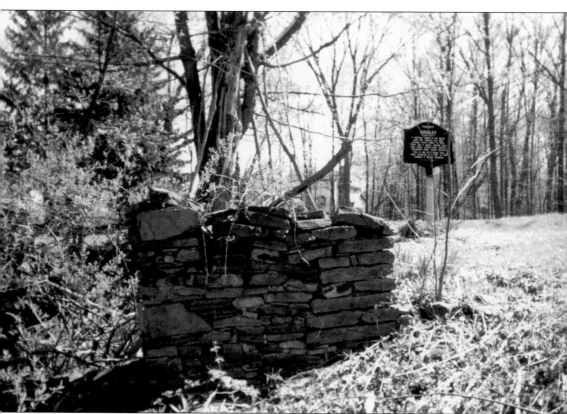

Although it was once a thriving community, Shirley became much less important to North Collins after the railroad came through Kerr's Corners (now the village of North Collins). Kerr's Corners became the center of business and social activity. All that remains of the hamlet are a few dwindling stone walls along the creek and a historical marker, which reads, "A thriving village in the 1800s until the railroad was built through North Collins in 1872. There was a school, general store, post office, barbershop, tannery, blacksmith shops, cheese factory. This is the site of a wagon shop, later converted to a mill on the original J. Pfleger property."

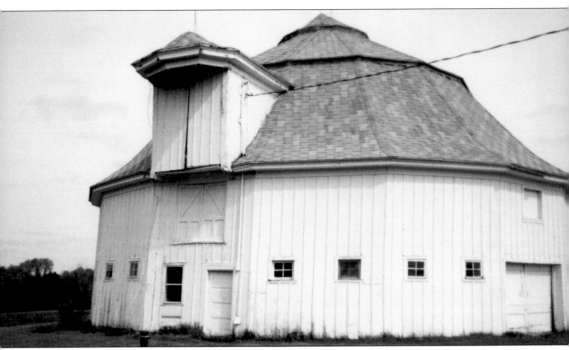

This "round" (16-sided) barn stands at the top of the hill on Shirley Road. The land on which it stands was originally purchased from the Holland Land Company by the Spaulding family. They hired a Swedish carpenter, Peter Falk, to build the house and barn c. 1901. The barn was once a working dairy barn and has become a local landmark. The house that had been built in 1901 later burned down; there is a replacement house on the property today.

Two

LANGFORD, CLARKSBURG, AND NEW OREGON

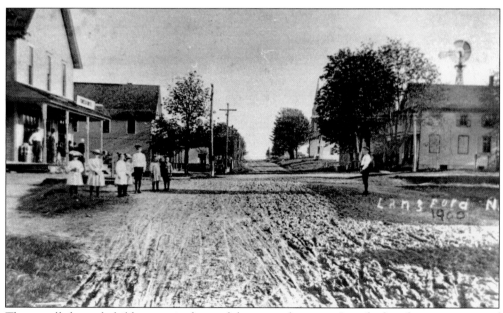

These well-dressed children are in front of the general store in Langford at the intersection of Sisson Highway (now Route 75) and Langford Road (now Route 249), which was the business district of the hamlet when this photograph was taken in 1900. The Dole Hotel (left) and another hotel (right) were on the south side of the intersection. Both buildings remain today. The St. Martin's Church steeple is visible farther south, on the right.

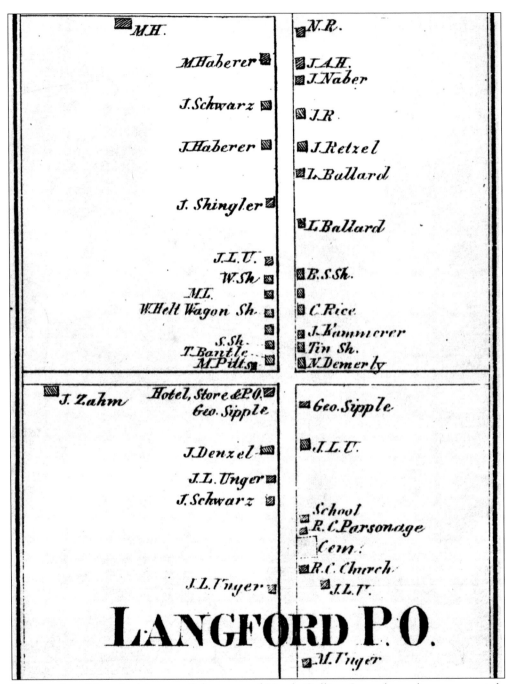

M.H.

M.Haberer

J.Schwarz

J.Haberer

J. Shingler

J.L.U.
W.Sh.
M.L.
W.Helt Wagon Sh.

S.Sh.
T.Bantle
M.Pitts

N.R.

J.A.H.
J.Naber

J.R.

J.Retzel

L.Ballard

L.Ballard

B.S.Sh.

C.Rice

J.Kammerer
Tin Sh.
N.Demerly

J. Zahm

Hotel, Store & P.O.
Geo. Sipple

J.Denzel

J.L. Unger

J.Schwarz

J.L.Unger

Geo.Sipple

J.L.U.

School
R.C.Parsonage
Cem.
R.C.Church
J.L.U.

LANGFORD P.O.

M.Unger

The hamlet of Langford is part of the town of North Collins. Its early settlers were mainly Germans, from Alsace-Lorraine, who had arrived c. 1835–1845, and English. In 1866, its residents included general store owners George Sippel and Nick Demerly; blacksmiths T. Bantle and L. Wolf; brewer and cheesemaker J. Schwarz; hardware dealer J. Kammerer; harnessmaker E. Reif; stock dealer Lewis Ballard Jr.; shoemakers J. Denzel and J. Nabor; teacher Henry Schmidt; tailor Michael Broesh; butcher M. Pitts; and cabinetmaker and undertaker A. Boller.

14

Dole's Hotel was located on the southeast corner of Langford-New Oregon Road and Sisson Highway (now Route 249 and 75, respectively). The building still stands at the corner, but the business has changed hands several times since these men posed in March 1916. Several of the men are members of the Dole family or their relatives.

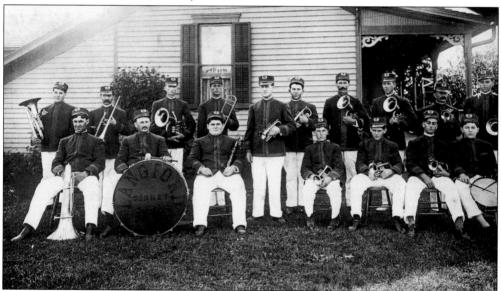

The Langford Cornet Band prepares for a parade at one of the member's homes. They are wearing white pants, dark blue jackets, and blue hats with their logo. From left to right are the following: (front row, sitting) Andrew Haberer, Joseph Ballard, Frank Thiel, Stanley Thiel, Kenneth Bantle, and two unidentified members; (back row, standing) William Dole, one unidentified member, Ed Gier, one unidentified member, Frank Bantle (local undertaker), three unidentified members, John Miller, and one unidentified member.

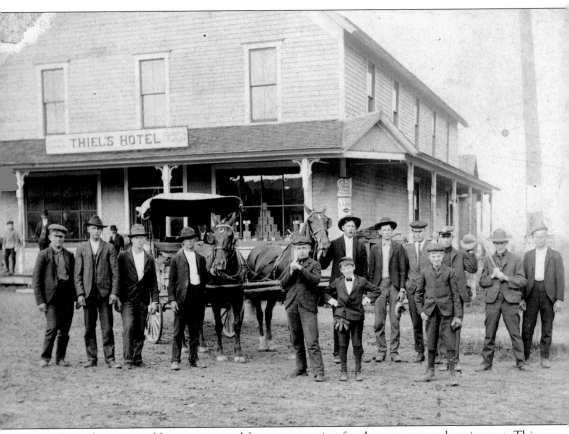

Perhaps the team and buggy were used for transportation for the manager and equipment. This picture was taken in front of Thiel's Hotel (and general store) at the center of Langford on July 7, 1903. The boy with the baseball glove peeking beneath his suit jacket is possibly the batboy. Close inspection shows two men holding bats and two others with gloves. This was probably not a league game, as there are no uniforms in sight. The building is on the northeast corner of Langford Road and Route 75.

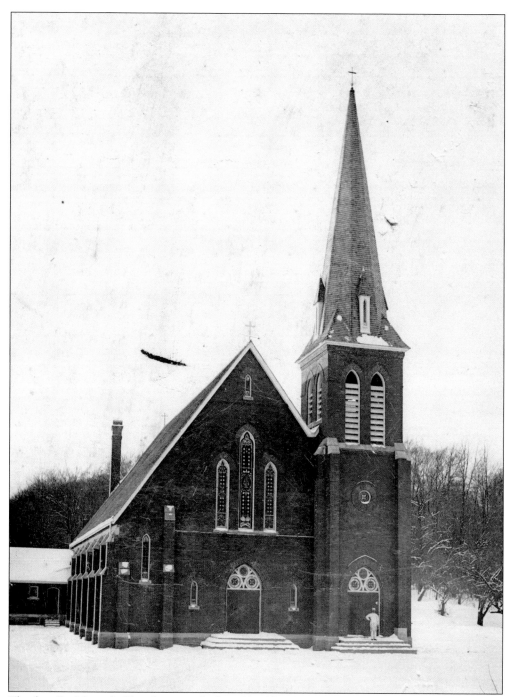

The first St. Martin's Church was a clapboard building built just south of Sippel's Corners (now Langford) in 1850, when the hamlet was 100 percent Roman Catholic and made up almost entirely of Germans. Land for the cemetery had been purchased in 1849. In 1902, the parish purchased an old brewery across the street from the wooden church, and the present brick and stone Gothic church was built on the brewery's foundation. The church had a succession of pastors, until Rev. Francis X. Schlee arrived c. 1880. He remained pastor until his death in 1909.

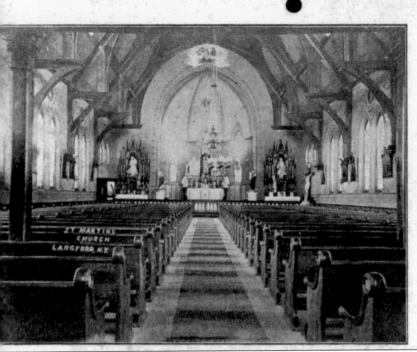

This is the interior of the then-new St. Martin's Church in 1902. The altars from the old wooden church were reconstructed in the new church. Stained-glass windows and a new bell were purchased. The bell had to be picked up at North Collins Depot and brought uphill to the church over a dirt road by a team of horses. Rev. William Burchhardt (pictured) succeeded Reverend Schlee as pastor.

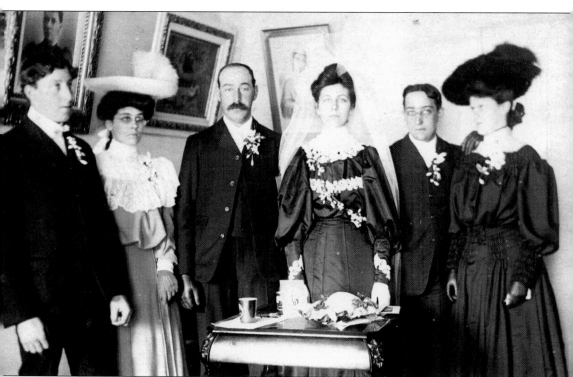

Louis L. Dole and Margaret E. Fox were the first couple to be married in the new St. Martin's Church, on Wednesday morning, January 18, 1905. For weddings in the 1800s and into the early 1900s, men wore ordinary suits and women wore dark dresses that could be used for other special occasions, frequently with a white tulle or lace veil, which could be used by others in the family.

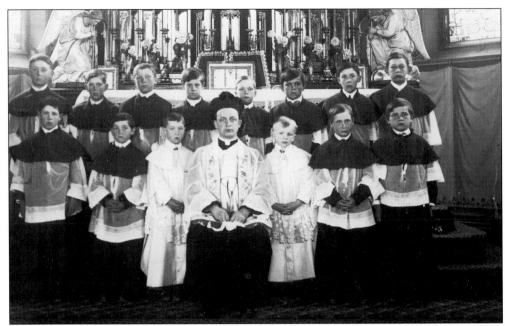

Reverend Burkhardt, the pastor of St. Martin's Church, is shown with his altar servers c. 1911. Note that the cassocks worn by the boys differ considerably from those used today. The beretta (hat) worn by the pastor is also rarely used in today's parishes.

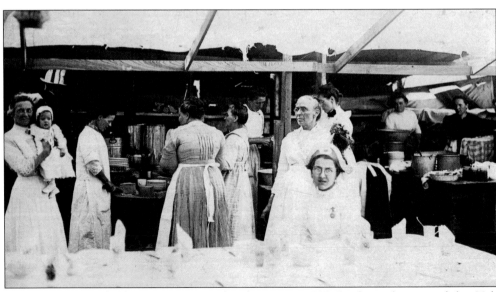

Picnics have been held at St. Martin's Church since c. 1900. In the early years of the 20th century, they were held in Thiel's Orchard (just behind the apartment building at the northeast corner of Routes 75 and 249). The parish became well known in the area for the wonderful dinners prepared by the parishioners. In recent years, the picnic has been discontinued, and several dinners are held in the church hall over the course of the year instead.

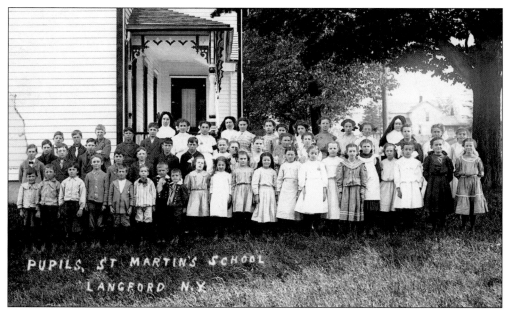

While Reverend Schlee was pastor, a school-convent was built at St. Martin's and operated by the Sisters of St. Joseph until it closed *c.* 1973. Among the families who sent their children to the school around the beginning of the 20th century were the Gohn, Brooks, Vance, Barthel, Rothfus, Peters, Dole, Bessinger, Naber, Falkner, Spengler, Bantle, Ballard, Bowman, Thiel, Zahm, Krebs, Smith, Haberer, Schreiner, Schneider, Cook, Anderson, and Emerling families. This photograph was taken *c.* 1910.

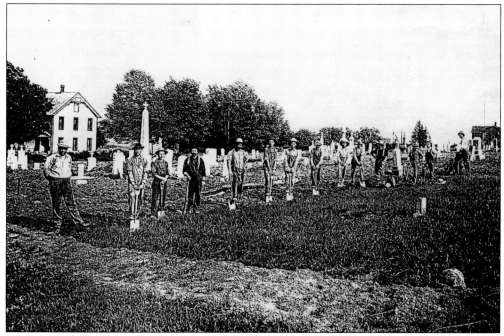

By 1872, the St. Martin's parish cemetery was full, and the present site, across the street, was purchased. Some of the tombs were moved to the new cemetery in order to utilize the land for other purposes. A work crew is pictured *c.* 1902.

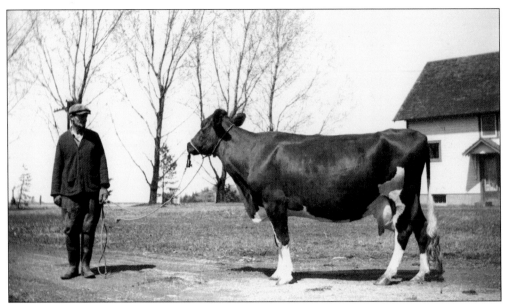

Avery Richmond shows off one of his prize dairy cows *c.* 1953. Area farmers have always been proud of their stock, many of which had pedigreed bloodlines as early as the mid-1800s. The registered stock was not limited to dairy or beef animals and horses whose bloodlines have been carefully recorded but also included assorted types of poultry.

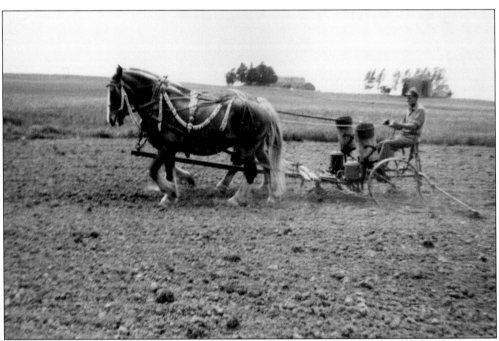

Richmond plants corn using a horse-drawn planter on the Richmond farm on Jennings Road in 1952. Although many farmers owned tractors by this time, some chores were still done by horse teams. Not only was using a team more practical on hilly ground, but also the farmers liked and trusted the teams they were used to using.

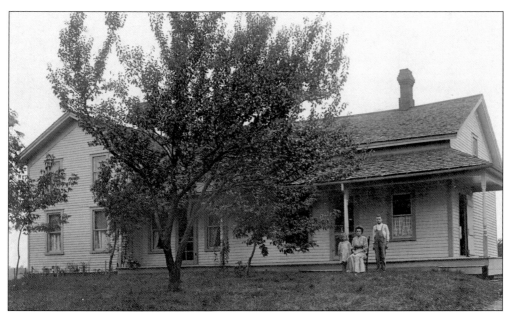

The Richmond dairy farm has been in the same family for more than 100 years. This home is the original Richmond homestead, which was located on the west side of Jennings Road just north of Langford Road. It is believed to be the Nathaniel Richmond family pictured on the porch. This house has been replaced by a modern home, owned by Charles and Mary Richmond.

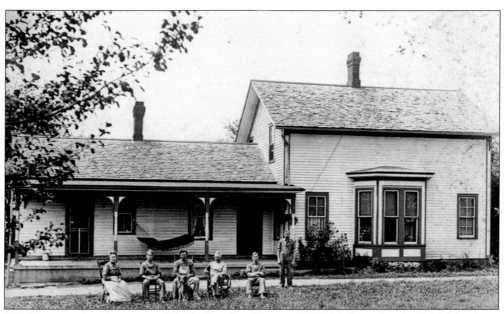

This homestead, at the corner of Shirley Road and Jennings Road, belonged to the C.M. Minekime family. Typically, when a family outgrew the house, additions were added to accommodate new members. Nearly all such farmsteads had a porch for relaxing, but not all included room for a hammock. Family members pictured on the lawn are, from left to right, Louise, Harry, Elmer, C. Mike, and Ray Minekime. William Linsler, their barn builder, stands on the right.

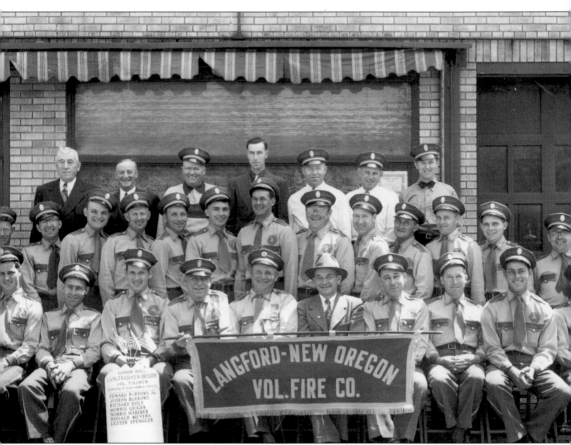

The Langford–New Oregon Fire Company was organized on October 16, 1944, by 22 men. Most of those original members are shown here in 1951. They are, from left to right, as follows: (front row) Joseph Geiger, Edwin Winter, Carl Korthals, Joseph Dole, John Spengler, Paul Bantle, Richard Stuhlmiller, Leo Winter, Clyde Dole, and Edward Carpus; (middle row) Francis Kohn, Al Wittmeyer, John Spengler Jr., Walter Wittmeyer, Wesley Beaver, Americo Beldaso, John Noto, Mark Peters, Elmer Winter, Joseph Heary, Edward Muehlbauer, James Wagner, and Roger Peet; (back row) William Winter, Ed Wood, William Schmitz, Howard Dole, Maynard Dole, Jerome Schmitz, and Earl Lawton.

By the time of its 50th anniversary celebration on July 10, 1994, the Langford–New Oregon Fire Company had grown in manpower and modern equipment. Present to celebrate are, from left to right, the following: (front row) Marland Schmitt, Paul Hohman, Robert Losey, Lawrence Minekime, Clarence Winter, Fr. Lawrence Damian, Rick Spengler, Richard Dole, Stanley Dus, William Niefer, Wesley Beaver, Walter Wittmeyer, Charles Muehlbauer, and Edwin Winter; (middle row) Stanley Kaminski, Joe Muehlbauer, Francis Kohn, Allen Schmitt, Ronald Schmitt, Charles Schmitz, Charles Hohman Jr., Francis Kohn Jr., Pete Loretto, David Winter, Richard Smolinski, Harold Wittmeyer, Ralph Mertle, Edward Muehlbauer, Howard Dole, and Clyde Dole; (back row) Dean Gallaway, Robert Stevick, Robert Kehr, Joseph Geiger, Donald Glow, Butch Berry, Donald Fox, Ronald Dole, Stanley Beaver, Marvin Winter, Kenneth Lawton, Robert Eder, Dave Schrader, Gene Spengler, Spike Hadley, David Schmitz, Paul Stuhlmiller, and Roy Schmitt.

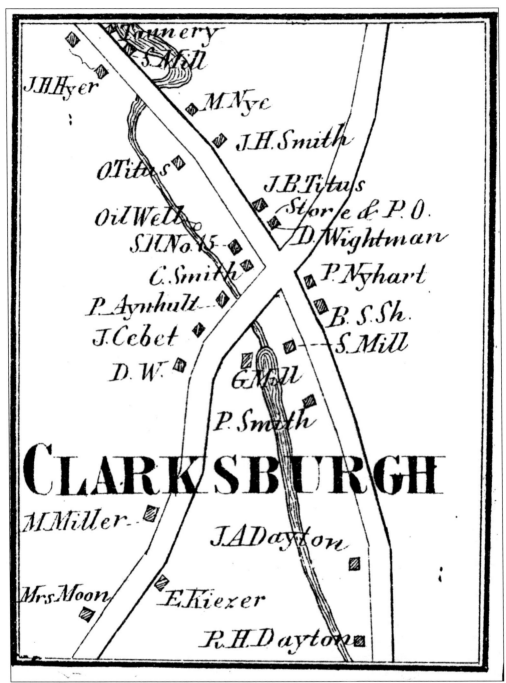

Clarksburg, a hamlet of the town of Eden near the hamlet of Langford, had its own oil well in 1866. Residents at that time included general store owner (and the owner of a planing, matching, and turning machine) D. Wightman; lumber and log dealer P. Smith; blacksmith P. Nyhart; tannery owner and lumber dealer J.H. Hyer; grist- and sawmill owner and flour and feed dealer Alexander Kromer; and J.H. Smith.

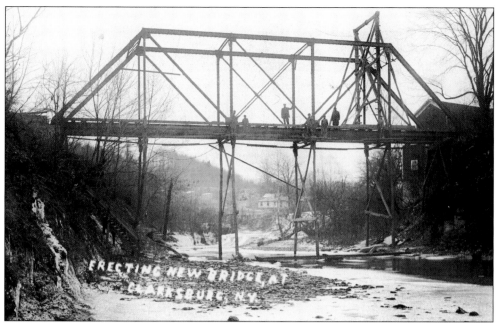

In 1911, the iron truss bridge was constructed across Eighteen Mile Creek at Clarksburg. It very likely replaced a wooden bridge at that time, but no record has been found of that. The iron bridge was built with one lane because traffic in the area was not considered heavy enough to warrant an expensive second lane.

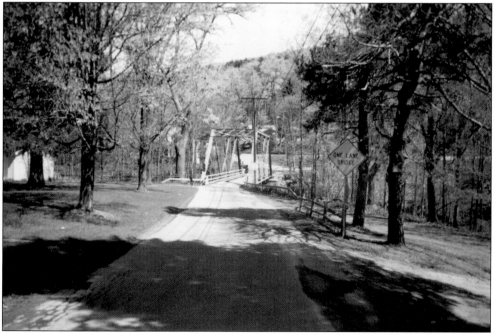

This picture, taken in 2002, shows the 1911 iron truss bridge over Eighteen Mile Creek (so named because it empties into Lake Erie 18 miles from the eastern end of the lake) sporting a new coat of orange paint. The road approaching it on both sides has been paved and has two lanes but is somewhat narrow. New Oregon Road runs across the picture at the back.

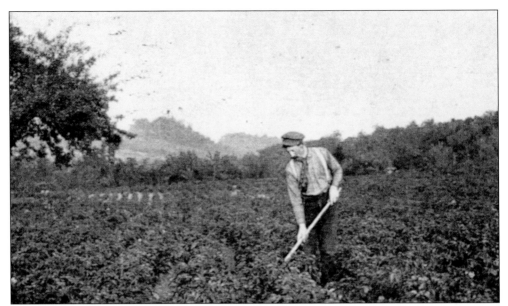

John E. Smith of Clarksburg hoes by hand a bumper crop of potatoes in this c. 1900 picture, which was used as a fertilizer advertisement by a Buffalo company. Since the rows appear to run in pairs with a slightly wider row after each pair, one might suspect that he normally loosened up the soil with a team of horses and a cultivator.

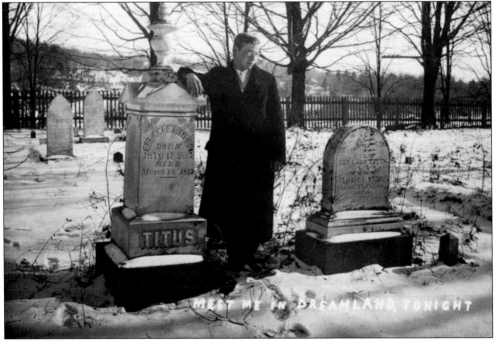

This small cemetery lies at the intersection of Clarksburg Road and Sisson Highway (Route 75). It is locally known as the Dittman Cemetery because many members of that family are buried here. The Titus monument, near the center of the cemetery, memorializes Orland S. Titus, who was born on July 17, 1837, and died on March 13, 1889. The stone to the right of the man is the memorial for the wife of Orlando Titus.

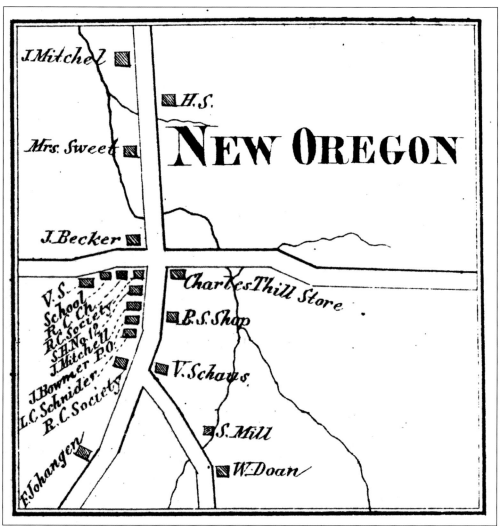

New Oregon is the easternmost hamlet of the town of North Collins. Its residents in 1866 included shoemaker and dance hall owner German (Germain) Schneider; general store owner Charles Thill; shoemaker F. Johengen; sawmill owner and lumber dealer William Doan; and residents S. Bevier (now Beaver), B. Taylor, J.W. Taylor, John Sisson, William Sisson, Charles C. Kirby, George Barringer, and Andrew Burley. Many of these men were involved in local government. New Oregon was also home to a carriage shop.

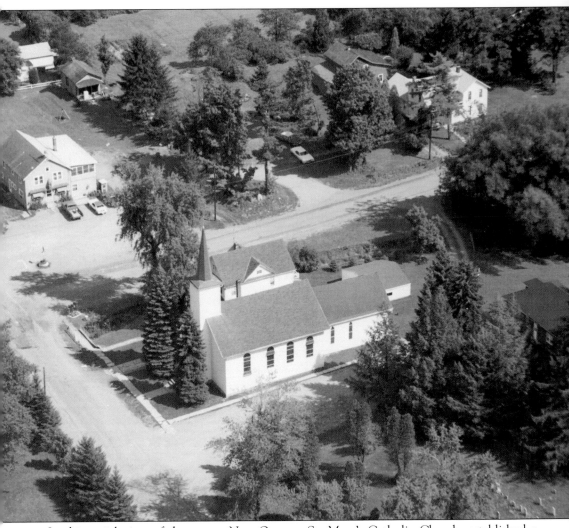

In this aerial view of downtown New Oregon, St. Mary's Catholic Church, established c. 1850, is at the center, and its cemetery is on the right. The small brick school of the parish, located behind the church, is now closed, but the building is used for other parish functions. The building across the road from the church complex is where Charles Thill used to have his general store and is now home to a restaurant and bar.

Three

MARSHFIELD, COLLINS CENTER, AND COLLINS

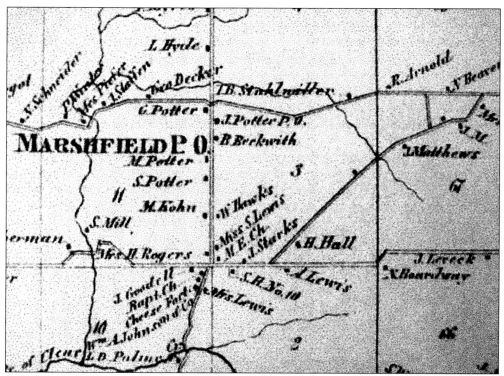

The tiny hamlet of Marshfield had two churches and two cemeteries in 1866. The Baptist church closed c. 1871 and was taken down c. 1896. There are no known records of the Methodist Episcopal church and cemetery, which had been abandoned for many years. The Marshfield Burying Ground, on the southeast side of the hamlet on Sisson Highway, is no longer active.

The crew was proud enough of this hand-stacked pile of oats to take this photograph in August 1910 on the Johnson Farm at the southwest corner of Genesee Road at Sisson Highway. Johnson had a prospering oat processing business. The oats were piled from the wagon with a long-handled, two-pronged stacking fork. When the stack was complete, the threshing machine was backed up to the pile and processing began.

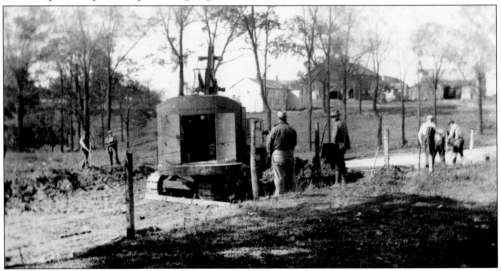

This heavy equipment was brought to Marshfield Road on June 27, 1927, to dredge the base for the first pavement. Some farmers even stopped work for a time to watch the steam shovel and grader at work. According to North Collins Town Board minutes, the town had upwards of 40 road overseers and one road commissioner. During the 1800s, each overseer was responsible for roads in the vicinity of his residence. It is not known whether the overseers actually repaired the roads or whether they merely reported problems to the commissioner.

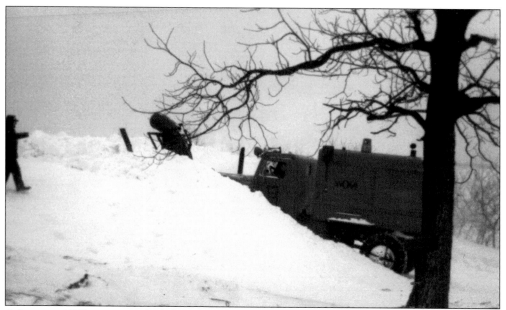

A January 1978 storm nearly defeated efforts to clear Marshfield Road with the town plow. The drift at this location, near Sisson Highway, was almost as tall as the large plow. Since this time, the highway department has acquired radar, which allows them to see the approach of storms and plan accordingly. The radar is also helpful in the summer, when weather can affect road repairs and other work.

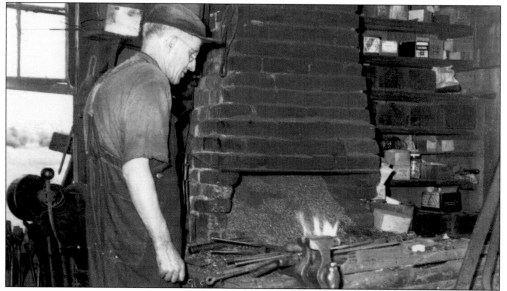

North Collins blacksmith Fred Gamel is at his forge on Genesee Road near the Collins dam. Frank Gamel, Fred's father, began the business in 1900. Having worked with his father since his teens, Fred took over the business in the 1930s and ran it until his retirement in the mid-1950s. They made horseshoes and shod horses, repaired farm equipment, and made everything from log hooks and pickaxes to ironing boards, laundry boards, and other items for the home. They also made repairs to rakes, spreader boxes, handles for hammers, mauls, and axes, and wood spindles for wheels.

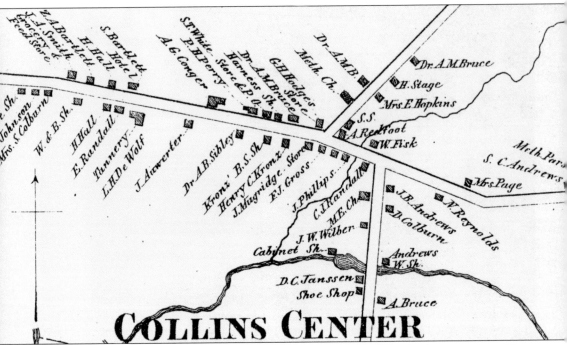

COLLINS CENTER

In 1866, Collins Center was a thriving hamlet of the town of Collins. At that time, its residents and businesses included the following: broker and mortgage dealer A.G. Conger; grocer J.A. Smith; general store and pharmacy owners Mugridge & Popple; tinsmith and stove dealer Albert Darby; blacksmith and wagon maker Henry C. Kronz; cheesemakers E.R. Harris & Company; lumberman Erastus L. Harris; tavern owner Seth Bartlett; shoemaker D.C. Jansson; cattle dealer Seth Harrington; Spanish Jack owner John Beverly; carpenter and millwright C.B. Parkinson; and farmer D. Newell.

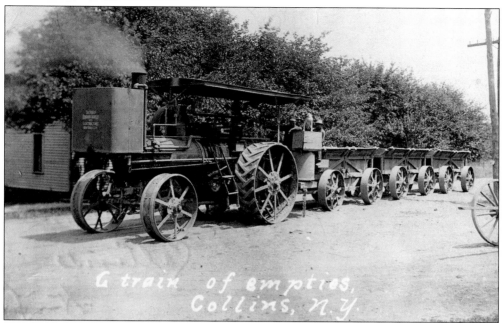

This line of empty hopper cars was used in early road building. The steam tractor pulled the three cars loaded with gravel or sub-base for the roads. They unloaded from the bottom so the material could be easily distributed across the roadway. Note the three crewmen and a small dog in the compartment at the rear of the tractor.

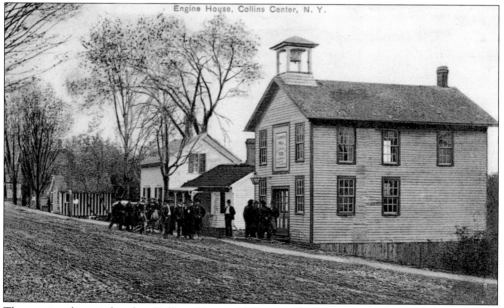

The engine house for the Collins Center Volunteer Fire Company, pictured c. 1900, was converted from a former wagon shop. The company moved to larger quarters, and the building was converted again, this time to a private residence. The building was destroyed by fire on December 18, 1991.

The Woodside Dance Hall is located in the hamlet of Morton's Corners, east of Collins Center. It was built as a luxurious private residence. It was converted to a dance hall that was widely attended by residents from all over southern Erie County. Square dancing was very popular, and well-known musicians played there in addition to local bands before the building burned to the ground.

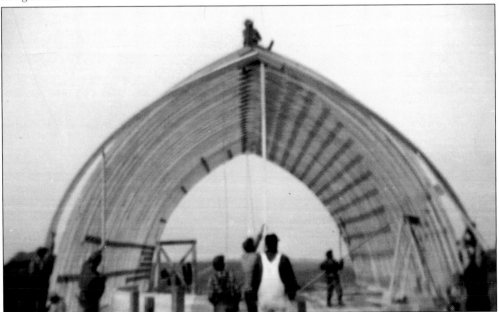

Many southern Erie County residents remember the square dances held at Wittmeyer's Barn every summer. When the hay was finished and the late hay not yet put in, the barn was thoroughly cleaned by the Walter Wittmeyer family. Then, square dances were held, every Saturday night during the summer season, frequently with music by the Midnight Rangers. The barn is shown under construction. The dance floor was immediately beneath the arches, and the dairy cattle were housed at the lower level, which the cows entered at ground level in the back.

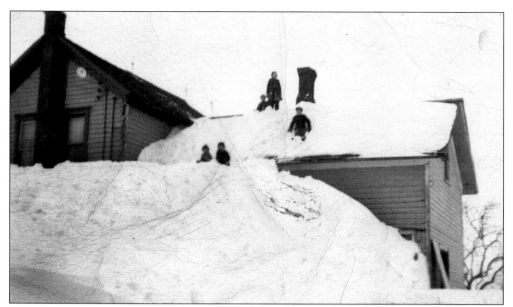

Many longtime southern Erie County residents remember the snowstorm of 1947. Winds piled the heavy snowfall into huge drifts that took several days to clear. The children of Walter Wittmeyer had fun climbing the snowdrift right onto the roof of their two-story house and then sliding down it. The storm, however, posed many problems for dairy farmers trying to get their milk out for market.

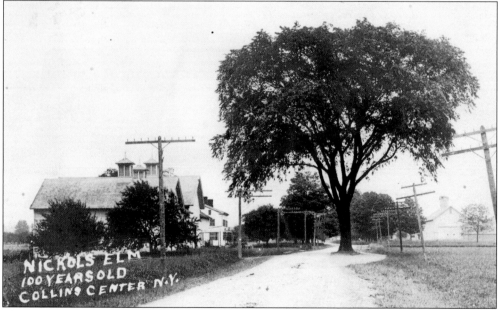

The Nickols Elm Tree was more commonly known as simply the big tree in the road on Route 39 between Collins and Springville. In this c. 1910 view, the road appears to pass around both sides of the tree. When the road was paved and widened, a bend in the road was created to divert drivers from the tree. Many sleepy drivers, however, did not make the bend. At one point, there was a special bank account set up for tree surgeon attention. When it became obvious that it would no longer survive, it was removed and the road was straightened.

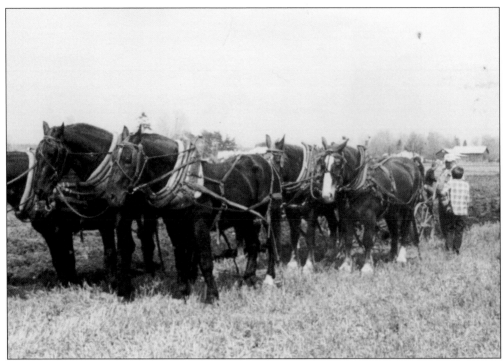

Since May 6, 1980, the Collins Draft Horse, Ox, and Pony Club has held the annual Plowing Festival and chicken barbecue in early May. The event has grown each year and now also includes a baked goods sale, historical exhibits, a petting zoo, raffles, musical entertainment, wagon rides, and pony rides. Pictured is a six-horse hitch at the May 6, 1980 event. This original event took place on Route 39 not far from the site of the Nickols Elm.

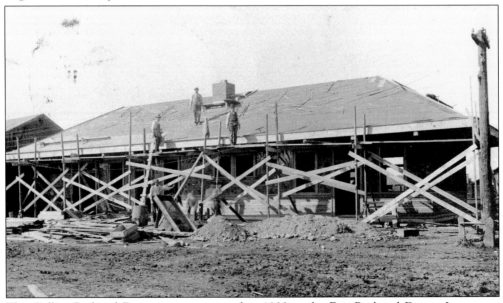

The Collins Railroad Depot was constructed c. 1900 as the Erie Railroad Depot. It was not likely the first depot there. The hamlet of Collins did not develop until after Collins Center, largely because of its location beside the railroad track.

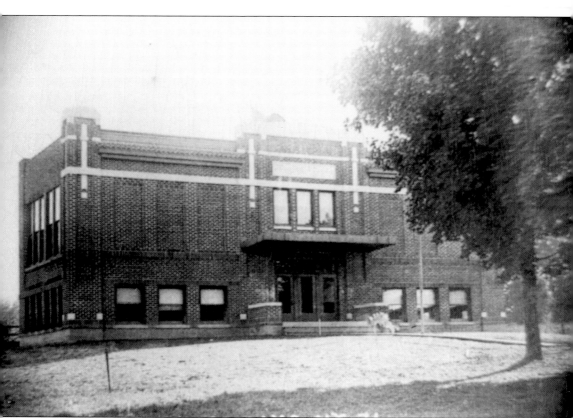

The first one-room school in the village of Collins was built in 1849. In 1887, a two-room schoolhouse was built. The brick School No. 3 (pictured) was built at Collins on Route 39 in 1917 to replace the one that burned. It remained in service until 1972. The tiny principal's office was located at the top of the stairs over the front doors. The school building became the L.K. Painter Center *c.* 1980. It now houses a day-care center and a variety of senior services.

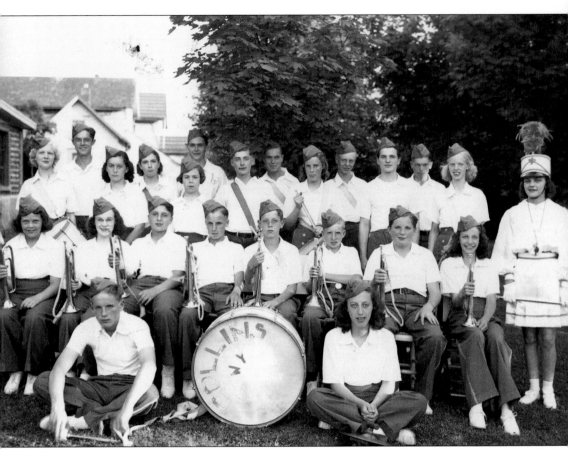

Collins firemen were accompanied by music during parades. The group even had its own drum corps. Pictured on June 16, 1939, are, from left to right, the following: (front row, on grass) Wilford Goran and June Volk; (middle row, seated) Irvine Johnston, Eva Birtchnall, Fred Burke Jr., Edwin Holland Jr., Robert Keller, Donald Juhl, Gurney Goran Jr., Norma Langless, and majorette Virginia Daniels; (back row, standing) Winifred Steele, Warren Moritz, Helen Pasho, Shirley Briggs, Lorna Rae Johnston, Harold Gibson, Fred Moritz Jr., Montgomery Deet Jr., Phyllis Johnston, Robert Young Jr., one unidentified member, Robert Studley, and Marie Young.

Four

GOWANDA
AND LAWTONS

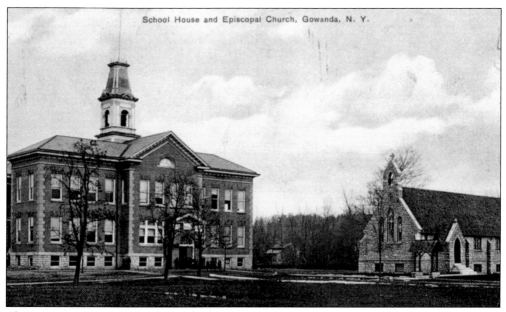

School House and Episcopal Church, Gowanda, N. Y.

The cornerstone at Gowanda Methodist Episcopal Church bears the year 1832, but records extend back only to 1835. At that time, the church was on the Lodi Circuit, and there was a schoolhouse on the same lot on which this church was built. In 1887, the building of this church was begun under pastor Rev. G.M. Harris at a cost of about $12,000. It was dedicated on February 29, 1888, by Bishop Hurst.

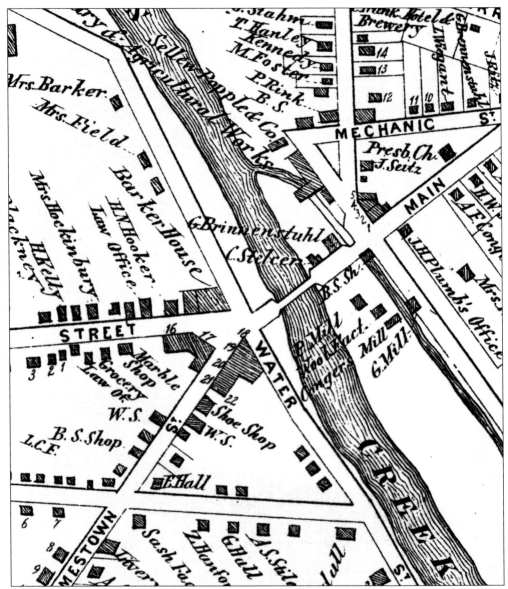

Spanning Cattaraugus Creek and situated in both Erie and Cattaraugus Counties, the village of Gowanda was part of the town of Collins in 1866 but is now part of the town of Persia. In 1866, its residents included Dr. Johnson, millwright Whitman Clark, foundry foreman Wilber Waters, machinist C.A. Smith, ironwork manufacturers Popple & Company, cattle dealer D.N. Brown, cider maker William Press, miller Allen Clark, a mortgage dealer, attorneys, cheesemakers, grocers, hotel owners, farmers, lumbermen, a pharmacist, brewers, and general store owners.

Before 1849, there were two school districts in the village, each with a small schoolhouse. One was located near the Methodist Episcopal church and one the old red schoolhouse on Buffalo Street. The districts were combined and a school was built in 1844. It became Gowanda Union School in 1866. The schoolhouse burned down in 1874, and another wooden structure was built before it was replaced by the building seen on the previous page. At one point, the school held approximately 500 students.

42

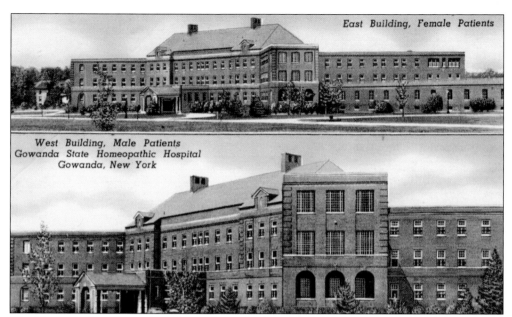

East Building, Female Patients

West Building, Male Patients
Gowanda State Homeopathic Hospital
Gowanda, New York

The Homeopathic Hospital at Gowanda was built in 1894. It was renamed the Gowanda State Homeopathic Hospital by the mid-1930s and later became the Gowanda Psychiatric Center. There were two large wings, one each for male and female patients. It shared its campus with the Gowanda Correctional Facility beginning in 1992 and closed in 1995, at which time the Collins Correctional Facility took over the remaining campus facilities.

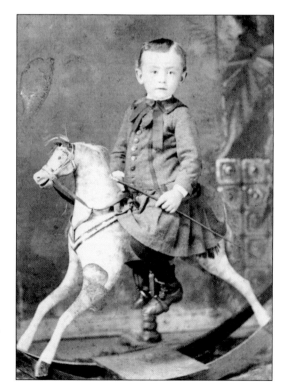

This picture of Elmer Lawton was taken at George W. Scott's studio in Gowanda c. 1880. During this period, small boys and girls both wore dresses. The easiest way to tell whether the child was a girl or a boy was to look at their hair. Boys wore their hair parted on the side, and girls wore their hair parted in the center.

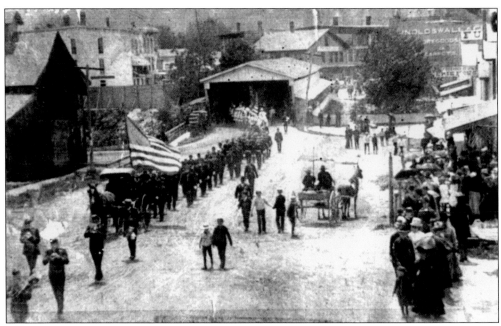

Decoration Day (now Memorial Day) was so named because it was the time to place flowers, wreaths, or flags on the graves of those who had served in the Civil War. On Decoration Day c. 1882, these members of the Gowanda Grand Army of the Republic and other units follow a brass band down Main Street in Gowanda through the wooden covered bridge across Cattaraugus Creek, thereby marching in two counties—Cattaraugus and Erie. The wooden bridge was built in 1862 and replaced by an iron truss bridge in 1889.

This picture shows the Main Street bridge crossing over Cattaraugus Creek from Erie County into Cattaraugus County. None of the businesses pictured remain. They were all destroyed by fire.

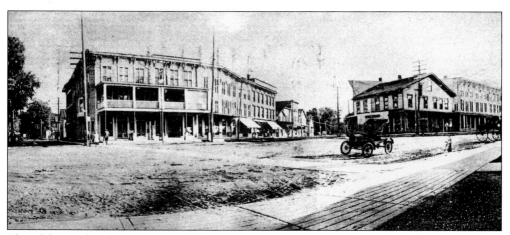

This elaborate hotel, pictured in 1907, was on the Cattaraugus side of the bridge but was long ago destroyed by fire. The building on the right is also gone. This spot is now the site of the Persia Town Hall. Water Street is at the left, Jamestown Street at center, and Main Street at the right.

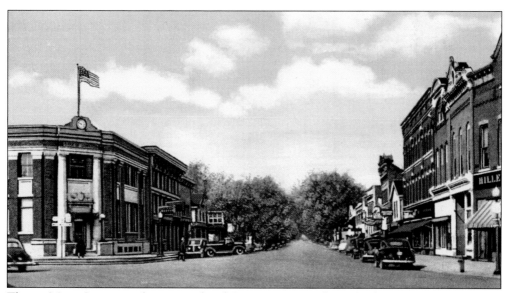

This is Main Street on the west side of Cattaraugus Creek in the heart of Gowanda. The building with the flag is currently the Persia Town Hall. Although most of the businesses have changed since this picture was taken c. 1940, the buildings remain in place with new occupants. The movie theater is now undergoing extensive restoration and renovation.

The Thomas Asylum for Orphan and Destitute Indian Children was located on the Cattaraugus Reservation. It began through the efforts of Rev. Asher Wright and his wife, who took orphaned and destitute Native American children into their home. Around 1854, the Indian Council dedicated 50 acres for an asylum and school for Native American children in New York State. It was incorporated by the state legislature in 1855 and became a state institution in 1875. At one point, the institution housed and educated 100 Native American children until they were 16 years old.

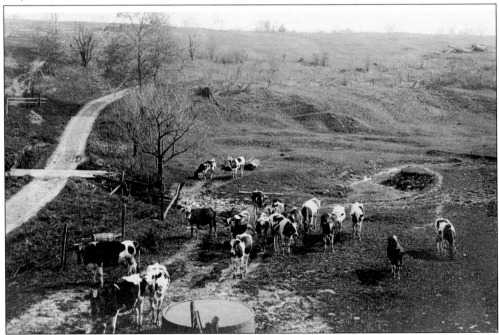

In the early 1900s, Jennings Road in Lawtons was a narrow dirt road like many others in the area. The bridge on the left has been replaced more than once since Jennings Road was paved. The Michael Boardway pasture abutted the road here.

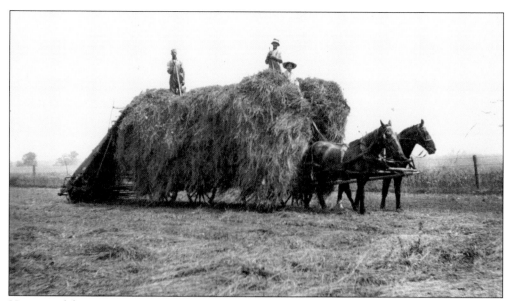

Horses and farms were inseparable in the early 1900s, when this photograph was taken on the Albert Boardway farm. The loading machine at the rear of the wagon had fork-like segments, which took the mown hay onto the wagon. The team then took the load to the barn for storage.

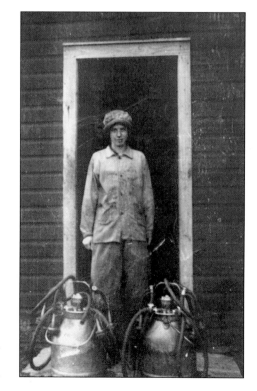

The first milking machines came to farms in this area *c.* 1916. Josephine Boardway stands in the dairy barn door with the two new milkers owned by her father, Joseph Boardway, in 1917.

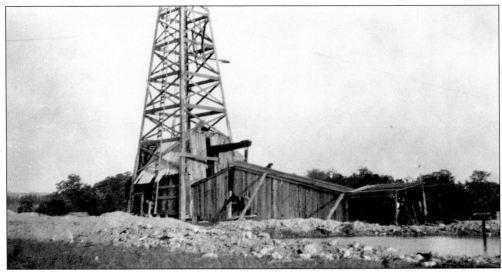

Many farms in southern Erie County had gas wells drilled between the mid-1800s and early 1900s. While some came up dry, a few still deliver commercial rates of production today. Other wells, whose production was not sufficient for commercial use, were sold to the farms on which they were located and used for heating residences and outbuildings. This well was being drilled on the Albert Boardway farm *c.* 1910.

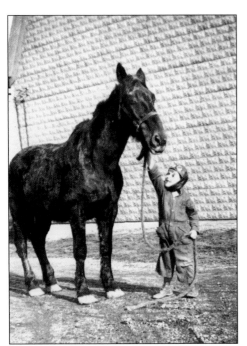

Left: Six-year-old Nelson Wittmeyer was not intimidated by the size of the workhorse he had been asked to hold. The picture was taken on his family's farm in 1931. *Right:* Young Marion Heary pumps water in 1941 for Schoolhouse No. 11 on Jennings Road near Genesee Road. The pump was at the south side of the school. Nelson and Marion later married and celebrated their 50th wedding anniversary in 2001.

In 1938, and for a time thereafter, there was a Boy Scout camp on Jennings Road. Part of the camp included a bridged swimming hole. The camp was located on the rear, southern corner of the Joseph Heary farm but no longer exists.

Lawtons had its own post office beginning in the 1800s, when it was known as Lawtons Station. Pictured here in 1924 is Leon Andres, Lawtons mail carrier, and his rural mail sleigh pulled by Molly. Note the 18-month-old child accompanying him, wearing a Santa cap.

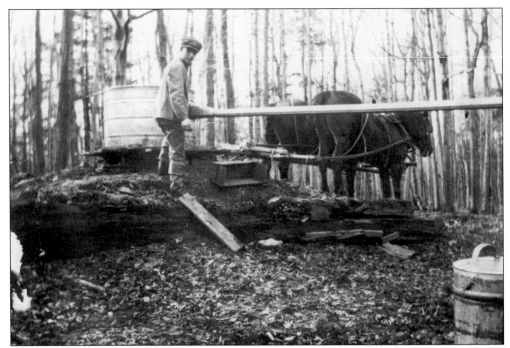

Many farms had their own sugarbush, or grove, of maple trees. The maple trees were tapped and the sap collected in buckets attached to the spigots on the trees early each spring. A big tank like the one pictured behind Joseph Heary would be drawn by horses to the sugarhouse for the sap to be boiled down. The sap would then be transferred to the sugarhouse via a pipe while a team waited patiently. This photograph dates from 1920.

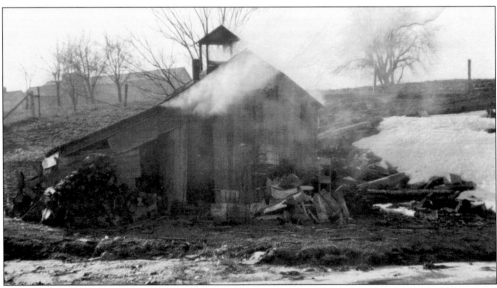

Once the maple sap was out of the sugarbush and into the sugar house, it was boiled down and very much reduced to make maple syrup. The different grades of syrup are defined by the time that the sap was collected, the first collection being the highest grade syrup. It was also boiled down further until maple sugar formed. This sugarhouse was on the Albert Boardway farm in 1920.

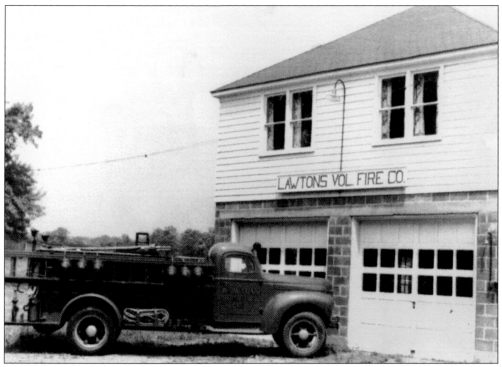

Lawtons Volunteer Fire Company was formed in 1945. Its fire hall was built shortly after and had two bays. This is the first fire truck, pictured *c.* 1950.

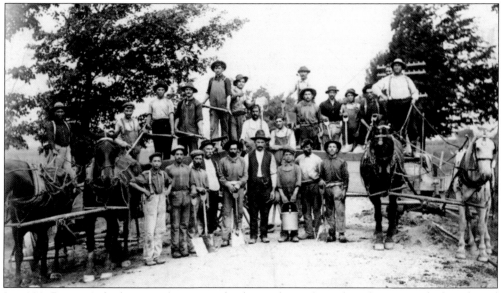

In 1908, Route 62 had not yet been paved. The work was later done by men with shovels and horses pulling heavy plow-like drags. The utility pole on the right did not carry electricity or telephone lines but a telegraph wire. The team of horses on the left belonged to William Ottenbacher. The team on the right was owned by "Uncle Willie" and was driven by Moses Cornplanter. Note the pail held by the young man at the center with the dipper handle sticking up. It was likely that his job was to take water to the men.

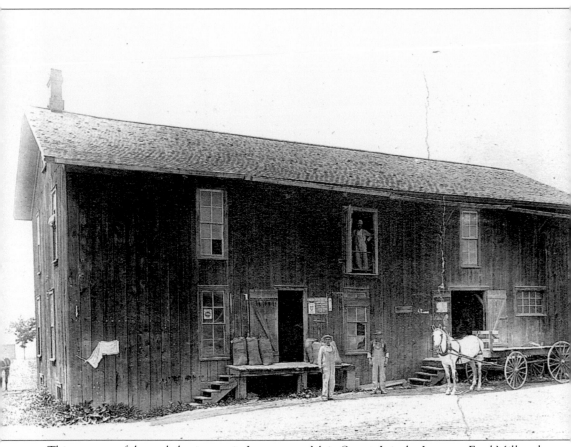

This was one of the early businesses in Lawtons on Main Street. It is the Lawtons Feed Mill and Slaughterhouse, operated by Leon Andres. He is pictured standing on the right by the horse in 1907.

Five

BRANT, FARNHAM, ANGOLA, AND PONTIAC

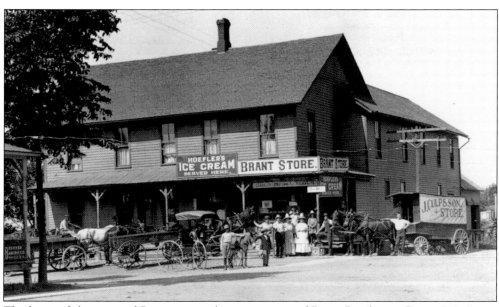

The heart of the town of Brant was at the intersection of Brant Road, now Route 249. It was then known as Brant Center. Among the businesses located there in 1911 was the Brant Store. It sold general merchandise as well as Hoefler's ice cream, according to the sign. The wagon of the J. Culp & Son Store on the right may have been making either a delivery or pickup at the time.

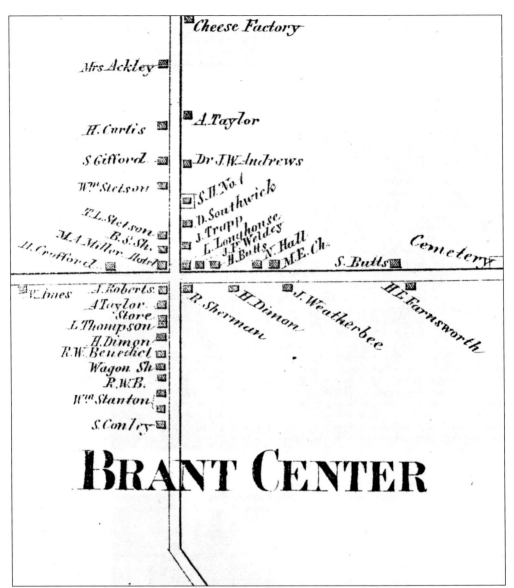

The hamlet of Brant Center became the center of the town of Brant. In 1866, its residents included doctor and surgeon J.W. Andrews; general store operator Levi Thompson; boot and shoe dealer Anthony Michael Taylor; hotel owner A. Miller; blacksmith John Trapp; a cheesemaker and wagon maker; and residents H. Curtis, S. Gifford, William Stetson, William Stanton, R. Sherman, D. Southwick, J. Weatherbee, H. Farnsworth, and others.

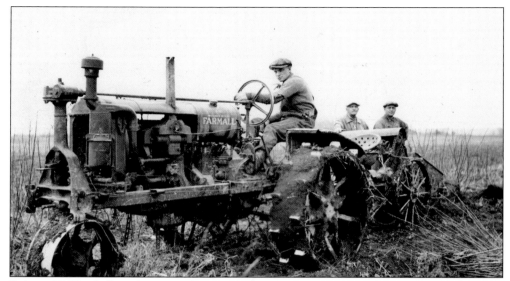

Robert W. Turnbull is shown on his tractor harvesting nursery stock *c.* 1938. Working the equipment at the rear are Robert R. Turnbull Sr. (left) and Alton Wheelock Sr. Turnbull Nursery Inc. was begun *c.* 1880, when Eugene Willett—son of Groton Willett, who brought some of the first grapevines to the area—began selling young vines he had propagated. It developed into Willett & Wheelock (until *c.* 1919), Wheelock & Congdon, Wheelock Nursery (*c.* 1930), and then Wheelock & Turnbull (1949). In 1998, it became Turnbull Nursery Inc., developer of the KOBRO digger.

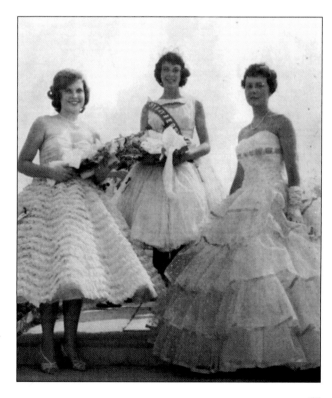

The strawberry queen at the fifth annual Brant Strawberry Festival in 1960 was Maureen Johnson. Her ladies in waiting that year were Nardena Lesefske (left) and Joan Rolleck (right).

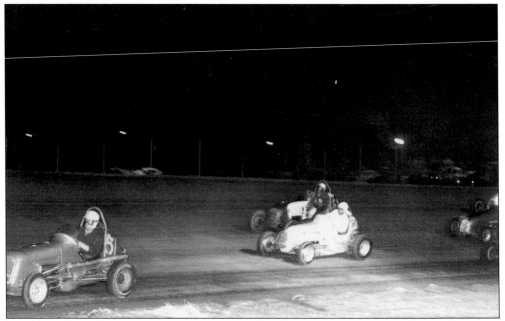

The midgets (car class) were a popular special event. Most of the drivers who participated in this series at Johnny's Speedway in Brant were not only from out of town but also from out of state. They are shown racing under the lights *c.* 1959.

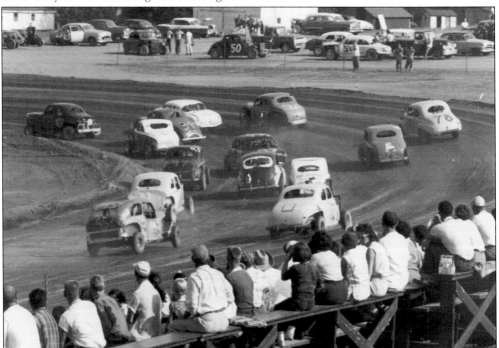

Johnny's Speedway in Brant opened in 1959 with super bomb stock cars and midgets. Bleachers held the fans who loved the dirt track racing. From here, the fans had a good view of the pits as well as all the action on the track. Local favorite drivers were "Stroker" McGurk, Joe DeCarlo, and Pepper Martin.

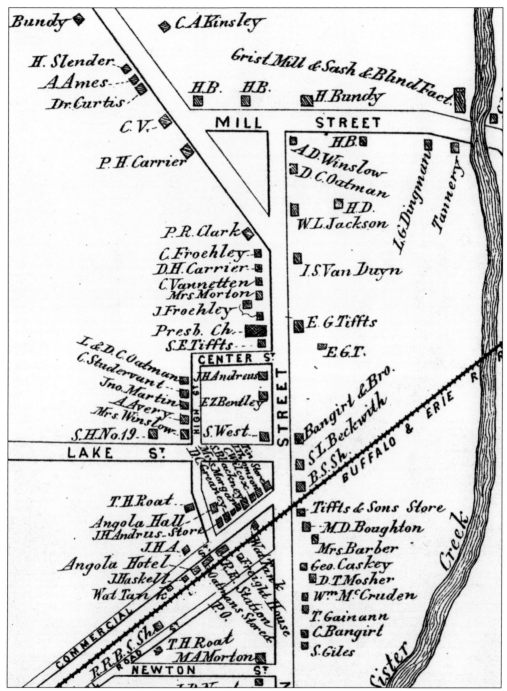

Evans Station developed into the village of Angola following the arrival of the railroad and the return of Civil War veterans, many looking for homes and land of their own. By 1866, Angola boasted its own deputy sheriff, George Caskey, as well as railroad agent J.M. Newton and Dr. Powers (the first resident physician in Angola). Businesses included the Angola Hotel, tinsmiths, wagon makers, grocers, general stores, harness maker, tannery, dressmaker, gristmill, footwear dealer, carpenter, cheesemaker, hops dealer, blacksmith, cooper, and furniture dealer.

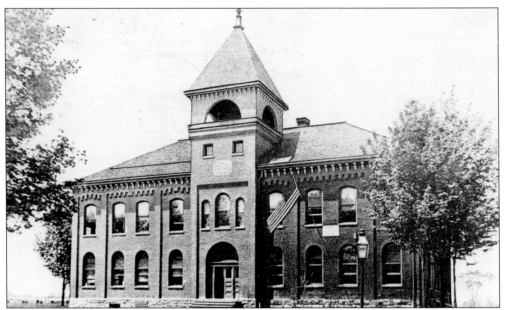

Angola Academy, the village's first large school, was built in 1884 and underwent several transformations throughout its history. The first was an addition in 1913. In 1936, the original section of the building was removed and a new section built onto the first addition. In 1968, the oldest section was removed and another new section built. The building currently houses the John T. Waugh Elementary School and is located at 100 High Street.

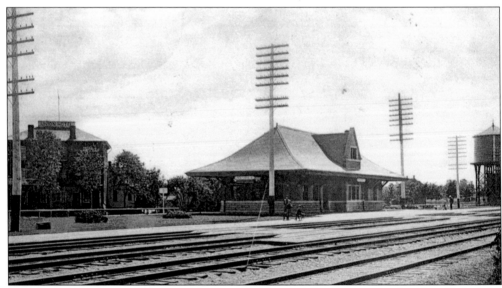

This railroad depot was built *c.* 1880 along Commercial Street to serve the New York, Lake Shore, & Michigan Railroad and became a depot of the New York Central Railroad *c.* 1917. The structure was removed after World War II to make room for the construction of an A & P grocery store.

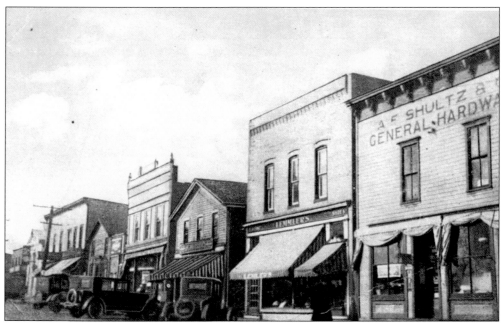

Commercial Street in Angola, shown c. 1925, was home to a thriving business district, the railroad station, and a small park around the station. Beginning on the left, the businesses of the time included the Bank of Angola, a library, a building housing Kingan's Jewelry, Retzel's Paper, and Taylor Ice Cream, a small building, Bob's Market, Blackney's Pharmacy (now Enchanted Glass Heart boutique), Lemmler's (now M & W Insurance), and Schultz Hardware.

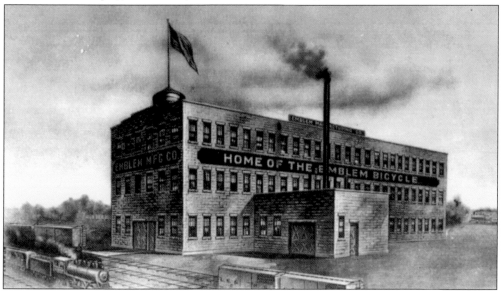

The Emblem Bicycle Factory of Angola began as the Pierce Cycle Company. Emblem began building bicycles in the fall of 1903 in an Idlewood barn owned by William Heil. In 1906, it moved to the three-story brick building near the railroad track on High Street in Angola called the Tifft Block and built an addition in 1910. At one time, it built bicycles and shipped them all over the world and for use in World War I. Like many other businesses, this one failed during the Great Depression.

FARNHAM STATION

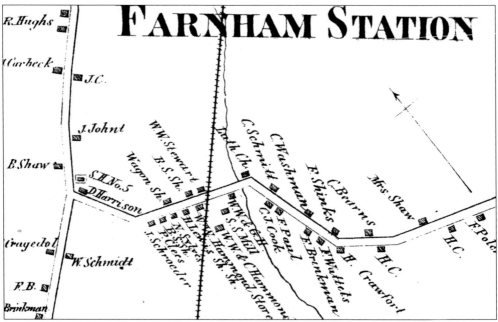

Farnham Station, also known as Mill Branch, is now the village of Farnham in the town of Brant. Its chief residents in 1866 were general store owner and attorney W.W. Hammond, steam sawmill owners W.W. & G. Hammond, blacksmiths William W. Stewart and Phillip Clees, boot and shoe manufacturers and retailers Henry Lewis and C. Jacob Cook, Lutheran church pastor Rev. P. Brand, and residents Hiram Crawford, F. Polchaw, L. Shaw, L. Turk, N. Case, John Siewert, F. Brinkman, John Gragedol, and Christ Siewert.

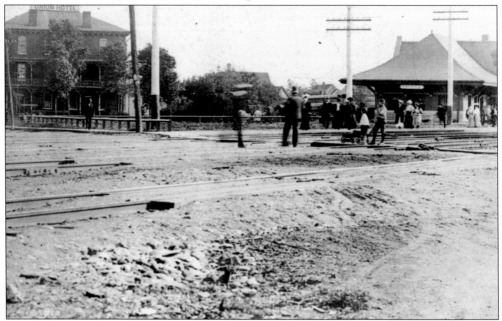

This railroad depot, in the village of Farnham, was built c. 1900 to serve the Lakeshore & Michigan Southern Railroad. The building on the left is a large hotel. Farnham had three stations—this depot, a station for the Pennsylvania Railroad, and a trolley station.

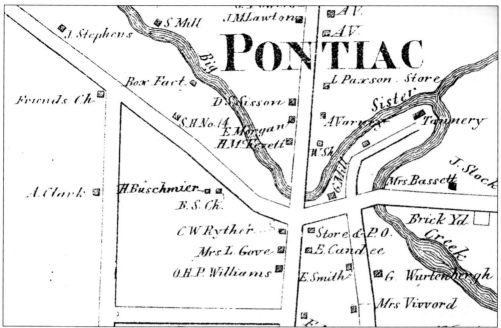

In 1866, Pontiac, a hamlet of the town of Evans, was on a main road between Buffalo and Versailles. Pontiac operated a tollgate north of Big Sister Creek. The brick School No. 14 still stands as a residence, but the tannery in the crook of Big Sister Creek is long gone. Businesses in 1866 included two general stores, three sawmills, farmers, and a builder and mover, cheese box maker, wagon maker, blacksmith, and brick and tile maker. A Friends meetinghouse had been in Pontiac since 1827.

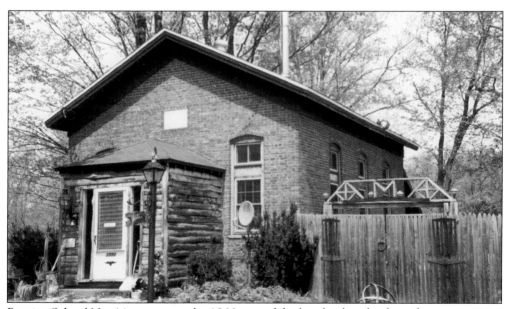

Pontiac School No. 14 appears on the 1866 map of the hamlet, but the date of its construction is not known. The structure has been remodeled into a residence. The stone designating this "Pontiac School No. 14" remains above the front entrance even today.

Pontiac Gristmill was originally built by Frederick Smith with the encouragement of the Holland Land Company. The gristmill was located at the northeast corner of the intersection of Pontiac and Versailles Plank Roads on the south bank of Big Sister Creek. At that time, it was in the settlement of Smith's Mills, but the name was soon changed to Pontiac after the famous Native American chief. In May 1924, the mill had been remodeled into a residence.

Harvesting potatoes was a different matter in 1929 than it is today. The grandchildren of the Smith family, for whom Smith Road is named, bring the bushel baskets of potatoes to the barn to unload. At that time, potatoes were picked up by hand and put into baskets. The horses got the crop from the field to the barn.

Six

KERR'S CORNERS AND NORTH COLLINS

The mullets were big and biting on this day in 1948, when James Alessi and his brother Joseph spent some time with little Joseph on the bank of Cattaraugus Creek just outside North Collins. Little Joey caught one too.

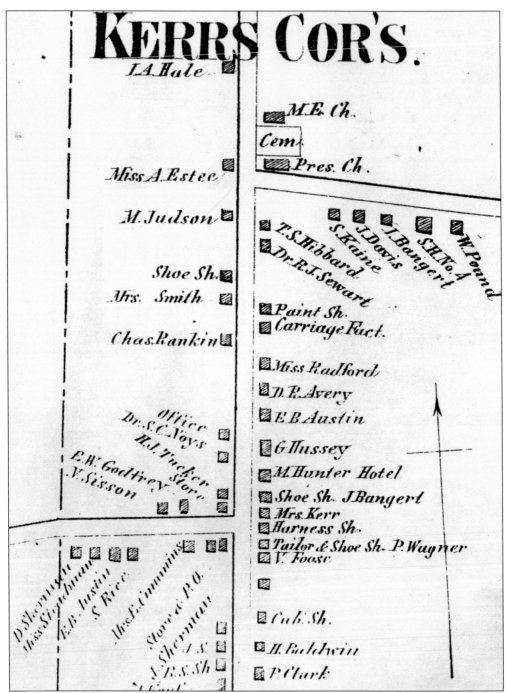

KERRS COR'S.

J.A. Hale

M.E. Ch.

Cem.

Pres. Ch.

Miss A. Estee

T.S. Hibbard
Dr. R.J. Sewart

S. Kaine

J. Davis

J. Bangert

S.H. No. 4

W. Pound

M. Judson

Shoe Sh.

Mrs. Smith

Paint Sh.
Carriage Fact.

Chas. Rankin

Miss Radford

D.R. Avery

E.B. Austin

G. Hussey

M. Hunter Hotel

Shoe Sh. J. Bangert

Mrs. Kerr

Harness Sh.

Tailor & Shoe Sh. P. Wagner

V. Foose

Office
Dr. S.C. Noys
H.J. Tucker Store

E.W. Godfrey
V. Sisson

D. Sherman
Miss Steadman
E.B. Austin
S. Rice
Mrs. E. Cummins
Store & P.O.
Sherman

Cab. Sh.

H. Baldwin

P. Clark

Kerr's Corners was a hamlet of the town of North Collins. It was incorporated as the village of North Collins in 1911. Among its residents in 1866 were hotel owner and photographer Michael Hunter; blacksmith and wagon maker J. Kopf; cabinetmaker and undertaker Victor Foose; shoemakers J. Bangert and E. Smith; general store owner Harvey Tucker; painter and paperhanger D.R. Avery; general store owners Estes, Godfrey, & Company; and assistant assessor William Rogers.

The village of North Collins acquired the property on Milestrip Road in the town of Brant, which contains its watershed, in 1916. At that time, the pipelines were installed, which still bring the water supply to residents. The first well had no concrete lining and was closed after several years when it failed to meet state health department standards; a new well was drilled. The water system has been upgraded several times by addition of new wells, pumping equipment, chemical feeds, and additional water lines as the village grew.

No one can verify whether this was the first water tower in the village. The village currently has two water towers located at the top of the hill on Sherman Avenue. They are inspected and maintained regularly, both exteriorly and interiorly, to meet New York State Department of Health standards.

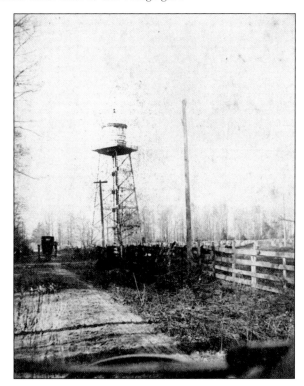

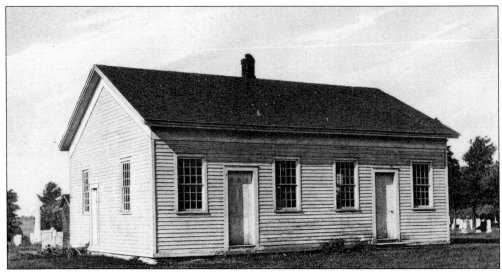

This Quaker meetinghouse at the front of the North Collins Cemetery was built by Hicksite Quakers in the 1830s following their breakaway from the Orthodox Meeting at Shirley. The area behind the meetinghouse was a cemetery. It is where the graves of many of the original settlers of North Collins can be found. The building has never been remodeled but has received needed paint courtesy of the Yorkers Club of North Collins High School, historian Grace Korthals, and in 2002 a joint effort of the North Collins Historical Society, Collins Quaker Meeting, the town and village of North Collins, and North Collins Cemetery Association.

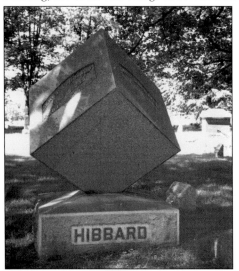
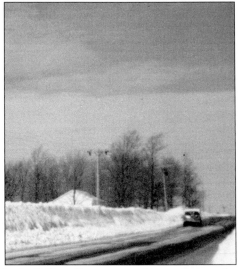

Left: Among the many unique grave markers in North Collins Cemetery is this tombstone for Enos Hibbard and his wife. Hibbard was a Civil War veteran and an influential member of the town. In the cemetery are several zinc monuments, which are no longer allowed to be placed for ecological reasons, and the town's only mausoleum, built for members of the White-Franklin-Sherman family. *Right:* The Blizzard of 1977 struck at midday, leaving so much snow so fast that many people were stranded away from home for two or three days. Schools were closed for a week while heavy machinery and plows dug cars from the drifts. Local stores were cleaned out of essentials by people arriving on foot. This photograph, taken nearly a month after the storm, still shows drifts higher than car roofs along Route 62 near Shirley Road.

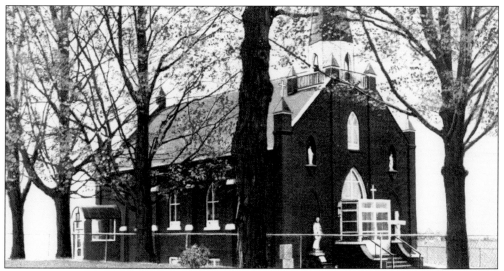

The church of the Sacred Heart of Mary was organized in the late 1920s by Rev. Jesus Juan Alvarez. A small chapel was built in 1932, and the present brick church was built to replace the chapel. The new church was dedicated on August 25, 1935, with ceremonies, bands, and flowers strewn around the church as the Holy Sacrament was carried from the chapel to the church. Reverend Alvarez wore long robes and frequently traveled with a lamb on a leash and a crow on his shoulder. The church became part of the Episcopal Diocese of Western New York on August 15, 1949.

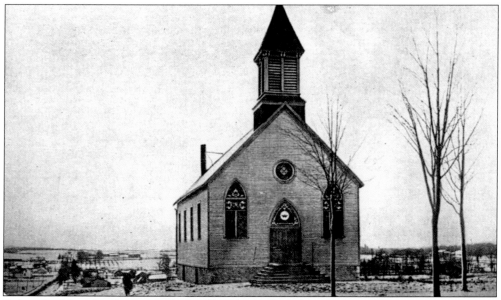

Before St. John the Baptist Catholic Church was built by Charles Hager on Brant Road just outside the village of North Collins in the town of Brant, services were held in the upstairs ballroom of Haberer House hotel. The parish had about 25 English-speaking families in 1904. After the church was built, a large horse shed was constructed for people coming from a distance who had previously had to leave their horses in the village and walk to church. The parish merged with Sacred Heart in 1948. A one-and-a-half-acre lot at the corner of Shirley and Gowanda Roads was purchased for cemetery purposes in 1905.

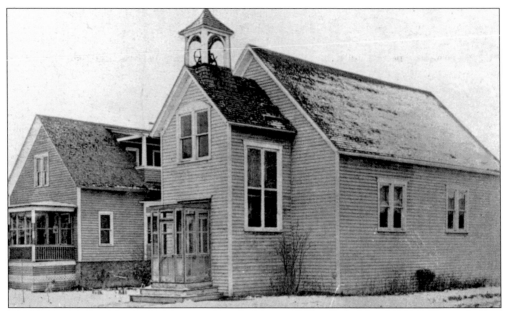

The first Italians in North Collins came largely between 1898 and 1907. During this time, Mass was said in a small frame building at the corner of Langford Road and Valone Street provided by Erie Preserving Company as a chapel, in the Pittro home on Railroad Avenue, or Schier's Hotel. The frame church was built at the corner of Spruce and High Streets by Charles Hager in 1907–1908 to serve Italian-speaking residents. The frame rectory was built beside the church on Spruce Street c. 1913. The cemetery of two and a half acres was located at the intersection of North Collins-Brant Road and Mile Block Road. The parish merged with St. John's in 1948.

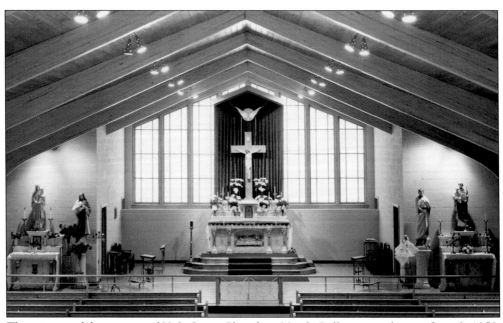

This picture of the interior of Holy Spirit Church in North Collins was taken on June 2, 1959, before the stained-glass window behind the altar was installed. Rev. Bernard A. Weiss, pastor, later had the stained glass removed and had a solid wall constructed behind the altar.

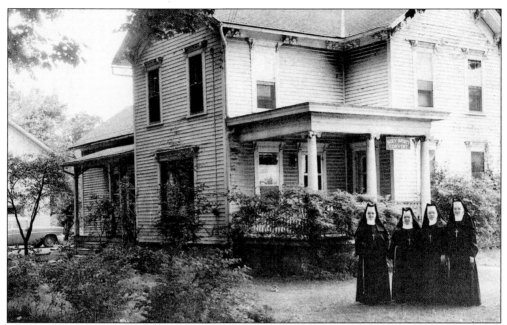

This house at the northwest corner of Main and Vermont Streets was the convent for the newly formed Holy Spirit parish. The four nuns who lived here c. 1960 are pictured on the lawn and are, from left to right, Sr. M. Presentia, Sr. M. Nazaria, Sr. M. Theorima, and Sr. M. Gaudia. The house was the home of the David Tarshis family from 1964 to 1984 and has since been the home of the Thomas Mudra family.

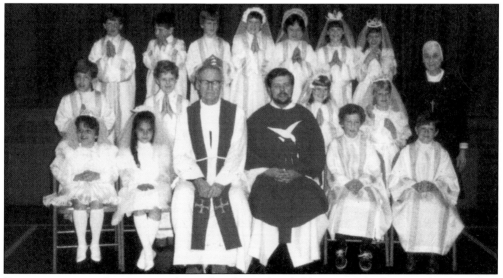

For many years, it has been traditional to have the children at Holy Spirit make their First Holy Communion on Trinity Sunday, the feast day of Holy Spirit. The First Holy Communion class of May 26, 1985, includes, from left to right, the following: (front row) Jennifer O'Boyle, Martina Abreu, Holy Spirit pastor Rev. Bernard A. Weiss, Rev. Robert S. Hughson, and two unidentified students; (middle row) two unidentified students, Jenifer Bowman, Nicole LeTrent, and Sr. M. Inviolate; (back row) three unidentified students, Jeannene Bergholtz, two unidentified students, and Shannon Swallow.

The First Congregational Church of North Collins was organized in 1817 by Rev. John Spencer, a Presbyterian minister. He was involved in the Holland Land Purchase and established numerous Congregational and Presbyterian churches on land donated by the Holland Land Company. In North Collins, the donated land was exchanged with property owned by the Standclift family, and the church has been in the same location at the northeast corner of Church Street (now School Street.) and Main Street ever since.

When the Christian Fellowship Church on Bantle Road in North Collins closed in the spring of 1998, the Wesleyan Church of western New York agreed to build a new congregation in the existing church and parsonage. Rev. Stan Kent arrived in June 1998 and found about 15 persons at his first service. The congregation has grown to about 150 and has an emphasis on youth and men's ministry. The picture shows the addition of the new church steeple. Many other improvements have been made to the church and parsonage, and the congregation continues to grow.

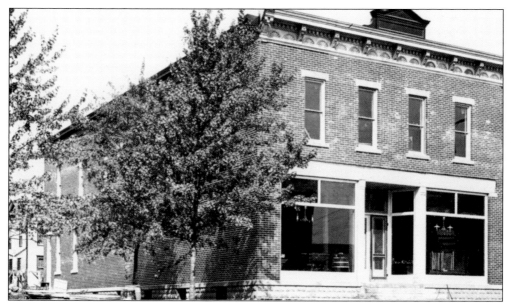

Shown c. 1908, this building on Main Street in the village of North Collins is the second building from the southwest corner of the intersection of Main Street and Brant Road. It once housed George Brown's Shoe Store and another business upstairs. More recently it housed the offices of Will Care on the ground floor and most recently was the service center for semi-independent handicapped persons.

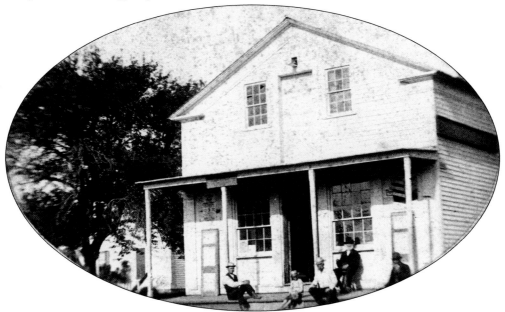

This building at the southwest corner of Main Street and Brant Road in the village of North Collins was known as the White Store. It was owned by David Sherman c. 1880. Here, Sherman sold grain and feeds. Note the large door upstairs at the front. There was a large wheel, or winch, upstairs that allowed barrels of molasses and other large goods to be hauled up and then lowered into the basement for storage. The building later housed Sobocinski's Pharmacy and Aunt Lucy's Kitchen. It is now C & L Just a Buck.

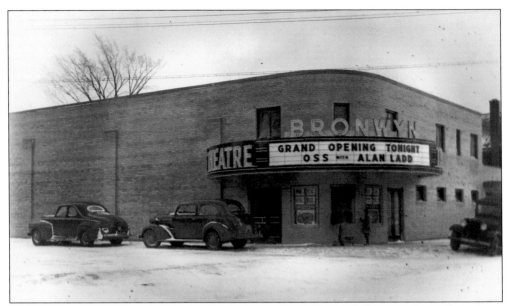

The Bronwyn Theatre was built at the southeast corner of Spruce and Main Streets. For years, it ran first-run movies. It is pictured at its grand opening in the 1940s. The movie showing at that time was OSS, starring Alan Ladd. The theater has since closed. The building was purchased by North Collins American Legion Post, and its use was offered to the community for meetings, weddings, and other occasions.

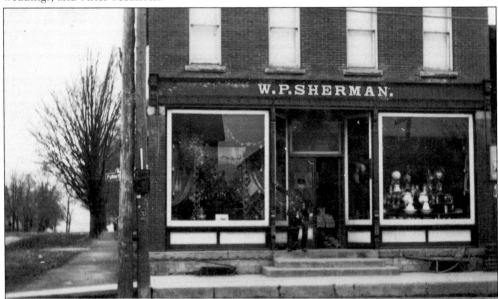

William P. Sherman was one of the first businessmen in the village of North Collins. The Sherman Block is a three-story building at the northwest corner of Main Street and Brant Road. His first clapboard dry goods store was so successful that it enabled him to construct this brick building and enlarge his business. The second floor was used as apartments. The third floor was a large hall, which was used by the community and then as the Masonic Room until the Masonic Temple was built. The store was succeeded by the Bolton store and then by the first Avery's store.

The W.E. Bolton store was located at the intersection of Brant Road and Sherman Avenue and Main Street in the village of North Collins. It sold a wide selection of general merchandise when this photograph was taken in 1949. The North Collins Masons held their meetings here until the temple was completed in 1921. The building now houses a business that produces award plaques and trophies.

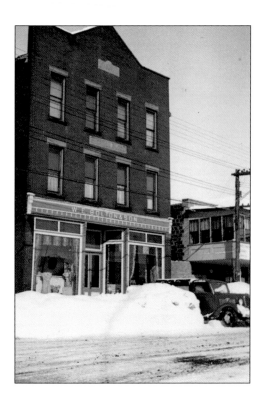

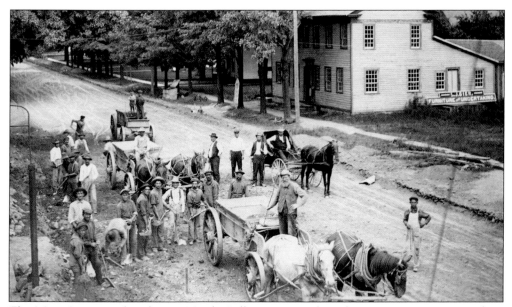

The Main Street road surface in North Collins seems to have been receiving attention from more than one crew around the beginning of the 20th century. The road had not yet been paved. Note the sign, which had either been removed or was prepared for hanging at the side of the building, "L.J. Gier, Furniture and Undertaking."

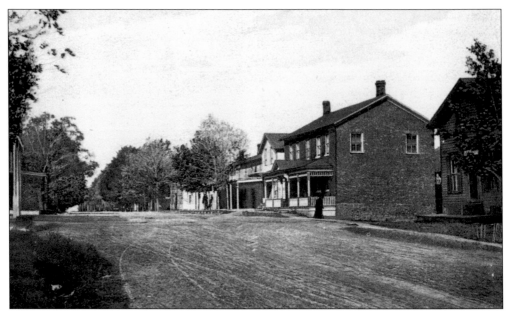

"The Square" in North Collins is presumed to have been the area where the traffic light is now located. The Sherman Block building is on the left edge. The white veranda protruding on the right center was part of a hotel where stagecoaches stopped; it since burned. In 1866, Brant Road did not yet cross the corner because the railroad had not yet arrived in town. By 1880, after the railroad arrival, this was a full, four-way corner.

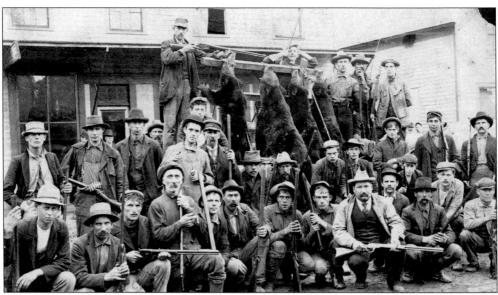

It must have been quite a hunt on this day c. 1880. The southern Erie County area had quite the wildlife population at that time. A closer look at the picture shows that there are two large bears and at least two smaller ones. They are believed to be racked in front of the harness shop or hardware store on Main Street.

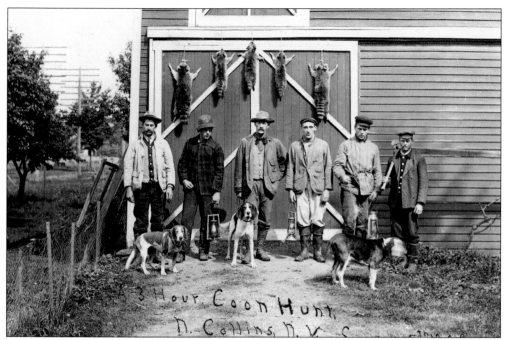

This was another successful three-hour hunt, but it is unknown just whose barn held the rack of pelts. Note that the hunters had their coon hounds with them in September 1909, when this photograph was taken.

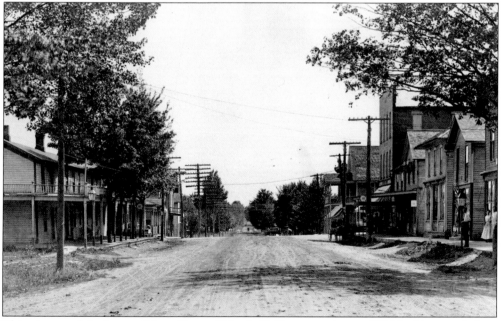

This picture of the heart of the village of North Collins was taken c. 1900 looking south from about the current location of the bank. The tall false front of the Sherman Block building is clearly visible on the right center. The Ruhling Harness Shop and Kiefer Brothers Hardware are closer to the right edge. The large building on the left was a hotel and stagecoach stop.

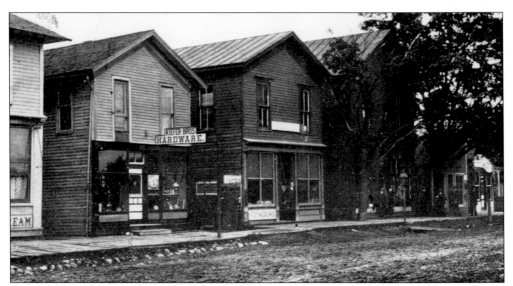

This closer view of the west side of Main Street shows Kiefer Brothers Hardware c. 1900. It stood between the Sherman Block building and the current bank location, in between Pittro's Ice Cream Parlor on the left and the pharmacy on the right. Note the tin roofs. These became common when village law required fireproof roofs.

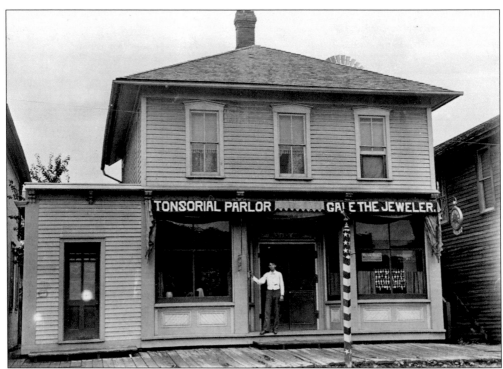

Also on the west side of Main Street a little farther north was the barbershop and the first Gale Jeweler business. Note the barber pole in the edge of the street before the door to the Tonsorial Parlor. Gale had his traditional, large watch hanging on the right side of the building. Note the plank sidewalks.

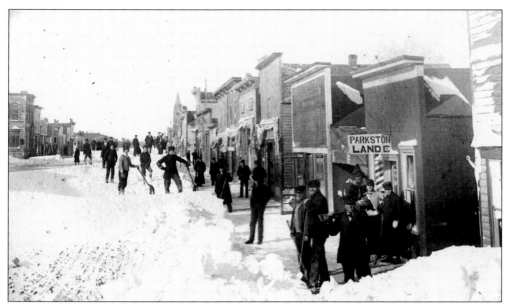

A snowstorm *c.* 1905 proved the cooperative spirit of the residents and businessmen to clear their streets and sidewalks. Newspaper items over the years verify that snowstorms occasionally dumped large amounts of snow, even in the village, although it frequently is much deeper "up the hill" in Langford, New Oregon, and Marshfield.

The James J. Alessi store was a Main Street fixture in North Collins for 45 years. Alessi and his wife, Josephine, opened their first store in the wooden Van Tassel building, pictured in 1944. The fire that destroyed the building, caused by an overheated furnace, had already begun. Note the wisps of smoke appearing at the left upstairs window and along the roofline and the firemen on the upstairs porch.

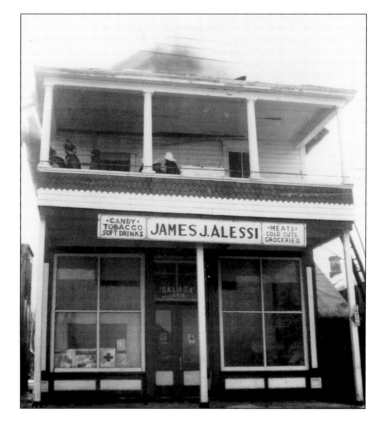

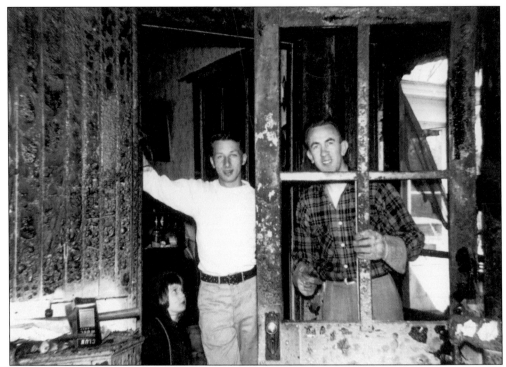

This picture was taken the day after the fire that finally closed Kiefer Brothers Hardware. The Kiefer brothers stood in the burned-out doorway for this picture. The store was located between the ice-cream parlor and the pharmacy on the west side of Main Street in North Collins.

Most residents knew this as the little building north of Speedy's Restaurant. It housed a variety of businesses over the years, including an ice-cream shop, barbershop, clothing boutique, and a beauty salon. In May 1988, Gier Development was hired to dismantle the building.

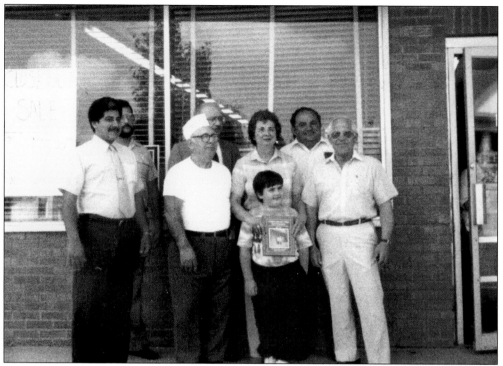

When Jim Alessi closed his store and retired on June 4, 1989, he was presented with a plaque in recognition of his years of service to the community by the North Collins Village Board. Shown, from left to right, are Village Trustees Michael Gullo and Mark Rivers, Jim Alessi, an unidentified person, Josephine Alessi, their grandson Jeffrey Ivanone, and Village Trustees James Mardino and Frank Compisi.

DJ's Market followed Alessi's market in the same building. Unfortunately, it was unable to remain open for very long and closed in 1989. The building now houses a successful pharmacy.

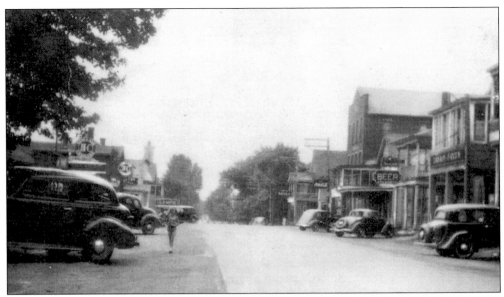

The business district in North Collins was thriving *c.* 1940. On the left, the Mr. & Mrs. Gas Station (the H.C. sign) and the Olympic Theater sign are visible between the Masonic Temple and the lunch car. On the right are Sobocinski's Pharmacy (south of the intersection), the Bolton store (Sherman Block building), Sam Pittro's Soda Fountain, Ruhling's Harness Shop, Barkler's Meats, Mike's Rustic Bar, and Danahy-Faxon Groceries.

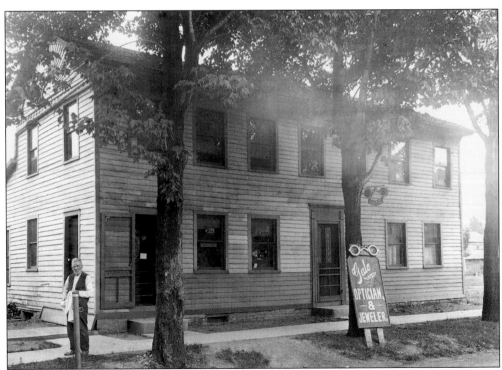

When his business expanded to include the sale of eyeglasses and jewelry *c.* 1910, Gale moved to a larger premises on Main Street. Note the spectacles on the top of the street sign.

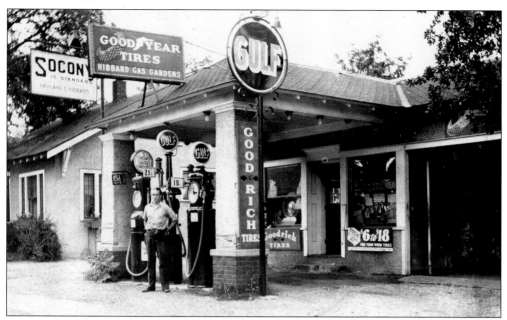

Mr. Hibbard is at the gas pumps of his station on Brant Road in North Collins *c.* 1938. Note the sign in the right window—"Special for 3 days only, $6 to $18 for your worn tires." Presumably, this was if you purchased a new set of Goodrich tires, which he sold. He also sold "Socony Motor Gasoline" (pump on the left) for 15$^1/2$¢ per gallon and Gulf gasoline at 21$^1/2$¢ and 18$^1/2$¢ per gallon. The station was later sold to Fred Kunderman.

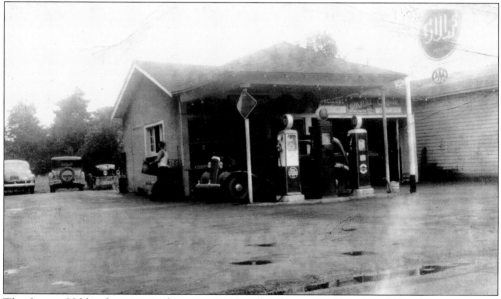

The former Hibbard station is shown *c.* 1946 under the ownership of Fred Kunderman. At this time, it also provided AAA service. Kunderman is just to the left of the building. The cars on that side of the building are a 1941 Chevy and a Hupmobile. The building to the right is the garage, also on Brant Road, used by Leo Gier for his hearse. On Halloween, the garage was frequently broken into and the hearse stolen. It would later appear at such odd places as the middle of the main intersection beneath the traffic signal.

This photograph of the Wallace Conrad or Subby Taylor Garage was taken c. 1950. The building is no longer there but stood between Speedy's Restaurant and the current Alessi Real Estate building on Main Street. The site is now a parking lot.

This c. 1940 photograph shows Avery Lawton's garage, at the northeast corner of Spruce and Main Streets. It later became the Tom O'Boyle Gas Station and is currently Shelly's Convenient Store. The building at the right is now the Vic Carriero office. The Forney home behind the station was removed; the North Collins Firemen's Training Center stands in that place now. The Bronwyn Theatre had not yet been built.

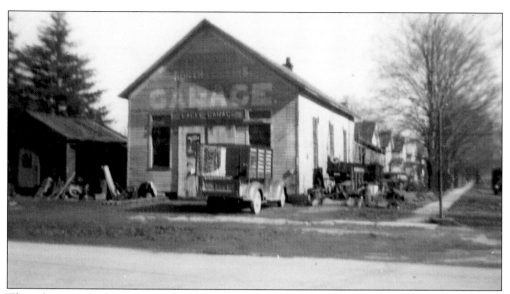

This photograph shows Frank Rice's garage, which stood at the northeast corner of Kimble and Main Streets in North Collins. It later was operated by Wilfred Feltz. The site is now the North Collins post office.

The Grand Army of the Republic log cabin meeting post is shown c. 1910 on Main Street. It was located in the area where the drugstore and bank parking lot are today. The cabin was later moved to Sherman Avenue. The picture was taken by Howard Briggs.

This view of Main Street in the village of North Collins looks north from about the bank location. The Bolton house is on the right. According to New York State Highway Department records, the Hamburg-Gowanda Road (now Route 62) received its first concrete pavement in 1919. A few years earlier, an oil and gravel surface was added, which the residents at first considered pavement.

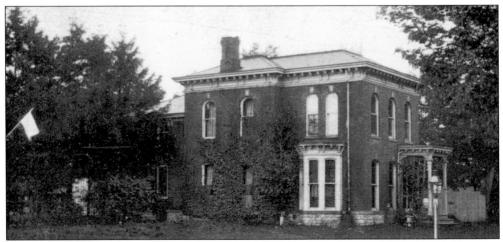

This view of the Enos Hibbard Homestead on the southwest corner of Main and Center Streets does not include the brick carriage house just behind the house. The carriage house later became the North Collins Memorial Library. Hibbard was one of the first members of the library. He was a Civil War veteran who married sometime after returning from his military service. The home is believed to have been built c. 1872. It was the site for many community activities, including everything from Boy Scout meetings to the local American Red Cross fund drive.

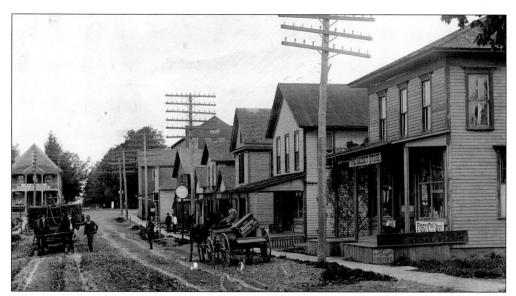

This c. 1900 view of Sherman Avenue looks west. The building on the right has a sign that reads, "The Racket Store." This was apparently a grocery or general store, since the sign on the porch advertises Gold Medal flour and postcards. The buckboard is carrying a large box labeled "Brummer Baking Co." Note the large round clock on a street pole in front of the horses and the barber pole between the men farther up the street. The building on the left is on Main Street—the W.E. Bolton store for general merchandise. The wagon approaching the camera is heavily laden with bales of hay or straw.

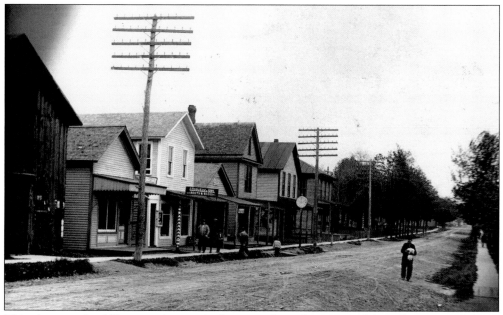

This photograph of Sherman Avenue looking east from the center of the village c. 1905 shows Rupp's Barn, Graham's Shoe Store, the Lindow Block, and the Pelegrino building. Note the wooden sidewalks to provide relatively dry footing for business customers.

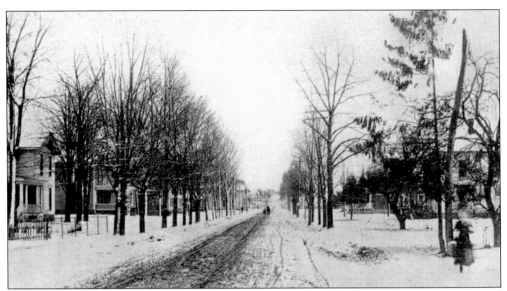

This c. 1910 view of Sherman Avenue looks east from the business district toward the railroad tracks. The residences here once housed the foremost families of the town and village of North Collins. Most of these homes still exist but many have been remodeled inside to become apartments. A careful look at the center of the picture reveals the balcony porches of the Haberer House, at the intersection of Sherman and Railroad Avenues. The house on the right is at the corner of Elm Street. The Harry Parker house was almost directly across the street on Sherman Avenue.

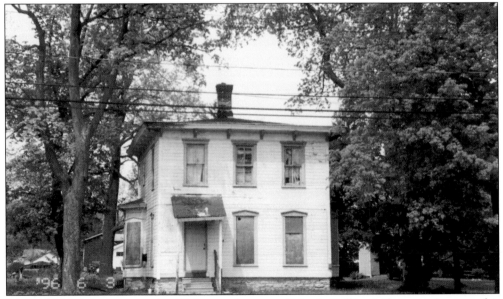

Situated on what was once the "Delaware Avenue of North Collins," Sherman Avenue, this luxurious home was once occupied by the family of Harry Parker, a station agent for the Erie Railroad. The home has deteriorated more than some of its neighbors. It was divided into apartments and used by seasonal laborers and others for many years. It achieved notoriety on November 5, 1977, when Sheriff's Deputy William F. Dils was shot to death in the building. The shooter escaped, and a massive manhunt was mounted until he was captured.

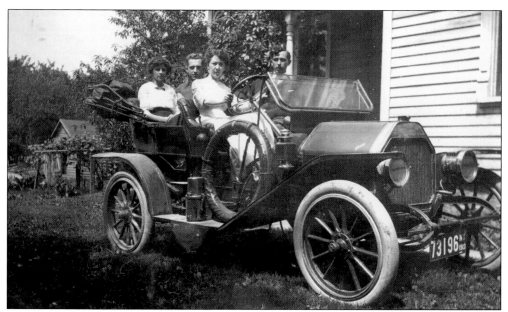

This was a great day in 1913 for driving with the top down. Ready to leave for a drive in the countryside are Dr. Worthington Ward (front passenger), Carolyn Ward (driving), and Mr. and Mrs. Davis.

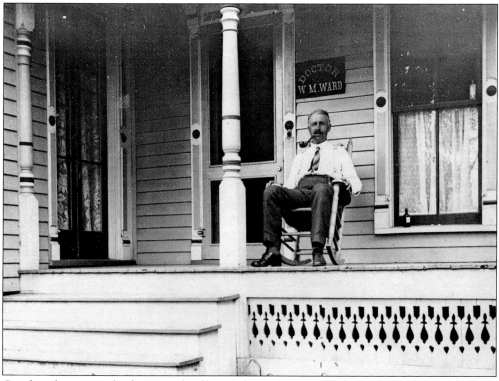

Caught relaxing on the front porch of his medical office, Dr. Walden M. Ward enjoys his pipe c. 1915.

John Falk is pictured in front of his home on Main Street in the village of North Collins in the fall of 1913. This house still stands in the village. It is now the second house north of the corner of Franklin and Main Streets on the east side of the street.

This was the residence of Dr. Walden M. Ward on Sherman Avenue c. 1915. During this period, Sherman Avenue was home to some of the most influential families in North Collins.

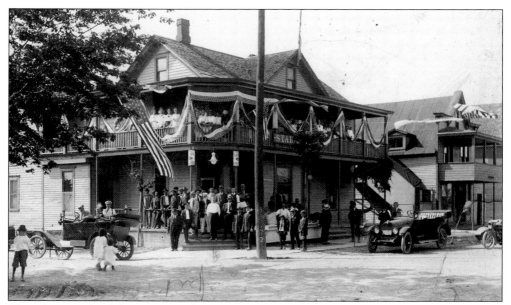

This photograph of the Star Hotel was taken on July 4, 1918. The hotel was located at the corner of Railroad Avenue and Spruce Street in the village of North Collins. The ladies apparently gathered upstairs and on the balcony, and the men and boys at street level. Note the motorcycle with a sidecar on the right.

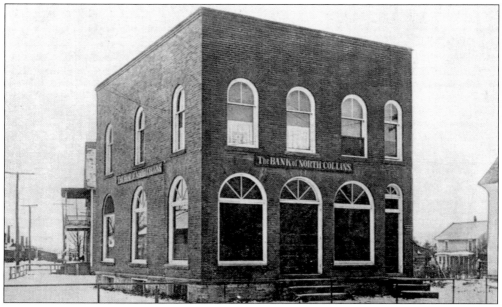

Around 1910, the Bank of North Collins was located at the foot of Sherman Avenue at the intersection with Railroad Avenue. It was in its heyday during the glory days of the railroad, being just across the street from the railroad depot and the Haberer House Hotel. It later moved to Main Street next door to the Enos Hibbard homestead. Since the bank moved, it has changed owners several times and is now Community Bank. This bank building became a restaurant after the bank moved, then a hotel, and has been remodeled into apartments.

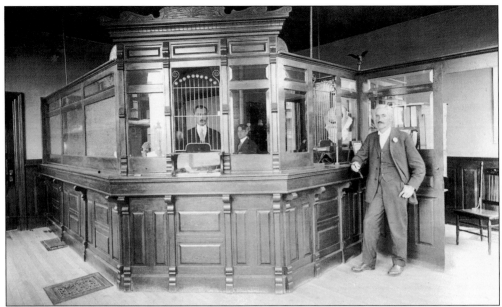

The interior of the Bank of North Collins spoke of its prosperity c. 1910. It stood at the intersection of Sherman and Railroad Avenues. Its interior was much more ornate than its exterior. The teller is Lee Ward, and the man at the rear of the teller section is unidentified. Standing to the right is Charles Twichell, bank president.

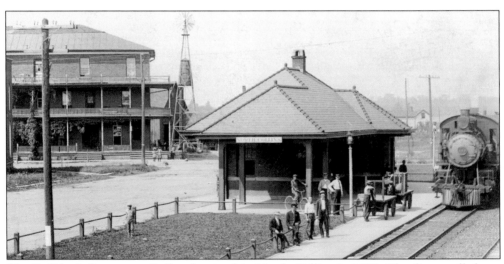

The Buffalo & Jamestown Railroad arrived in North Collins in 1872. The first small depot was at what later became known as Hibbard's Crossing. In 1873, the depot was moved to the southeast corner of Sherman at Railroad Avenues. In 1898, this much larger and nicer building was constructed, and the railroad had changed to the Buffalo & Southwestern. The line then changed to the New York Lake Erie & Western Railroad before becoming the Erie Railroad. The depot handled freight, mail, and passengers until 1950. At that time, all service except freight was discontinued. A restaurant was in the building for a short time after that. The building no longer exists.

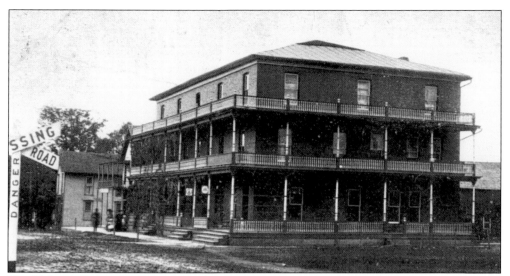

The Haberer House Hotel was in its heyday during the 1880s and early 1900s. It was not the first hotel at this location. It replaced at least one other, which had burned. The first floor held the public room and restaurant. On the second floor were rooms for rent. The third floor was a ballroom, where church services were held as well as community meetings, dances, graduations, and weddings. The building remains today as North Collins Hotel but without its glorious verandas on each story.

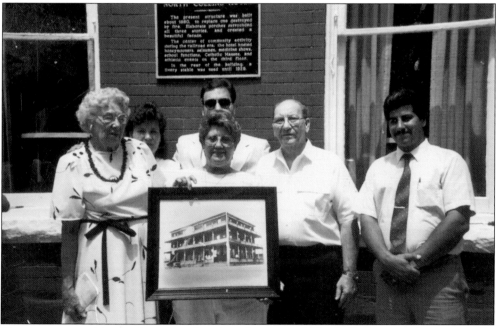

The most recent historical marker placed in the town of North Collins was this one, at the North Collins Hotel. During the glory days of the railroad, the Haberer House Hotel was the honeymoon hotel of choice. It had verandas around two sides of the hotel on all three floors. Pictured on the day of the plaque unveiling are, from left to right, North Collins historian Grace Korthals, hotel owners Dominica and Richard J. Taczkowski, and Mayor Michael Gullo. At the back are the children of the Taczkowskis, Nina and Richard L.

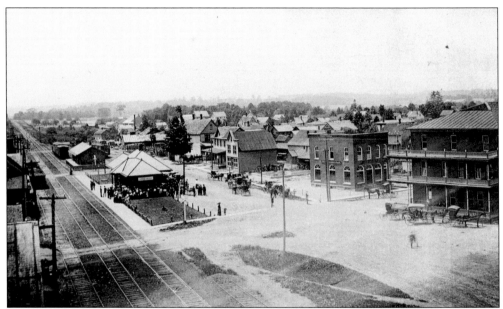

This unusual view of the railroad area c. 1900 in the village of North Collins shows the intersection of Sherman Avenue (crossing the tracks in the foreground) and Railroad Avenue along the west side of the tracks. The depot was used for both freight and passengers, who would stay at either Haberer House (on the right with verandas) or Star Hotel at the intersection of Spruce Street (near center with veranda across front). Along the east side of the tracks on the far left were the Erie Preserving Company and the Shale Brick Factory.

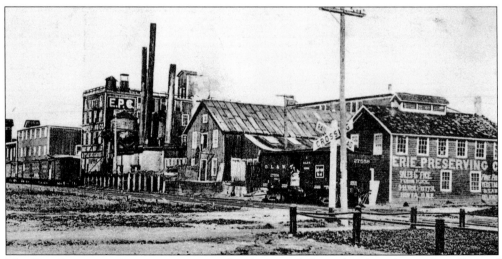

The Erie Preserving Company was immediately east of the railroad tracks in the village of North Collins. It served produce farms in the greater North Collins area, canning a wide variety of fruits and vegetables in season. Later, other canneries located nearby were the Helen Canning Company, Gro-Pac, Pro-Can, and others in the hamlets of Lawtons and Farnham. The first Italian immigrants to southern Erie County came mostly from Buffalo area from 1898 to 1907 to work in the canning factories.

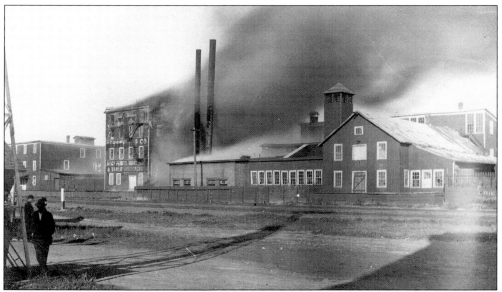

One Sunday afternoon in 1909, the Erie Preserving Company in North Collins was completely destroyed by fire. The company occupied several acres and included a number of large buildings and sheds along the east side of the Erie Railroad tracks, including an area known as the Klondike, which ran through to High Street on the north end of the plant.

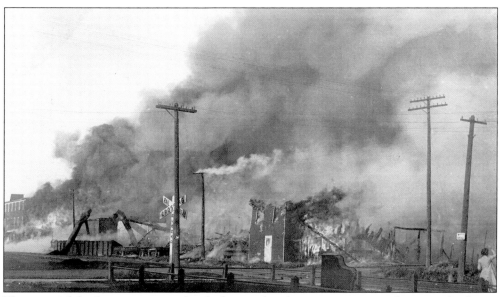

The cause of the fire was suggested to be hot cinders from a passing train, but since fire began on the fourth story of the main building, that is unlikely. The fire was first reported at around 4:30 p.m. by people on the veranda of the Haberer House Hotel across the street from the plant. It spread very rapidly due to a strong northwest wind fanning the flames. One house and a blacksmith shop were lost, but hard work saved other homes despite flying embers.

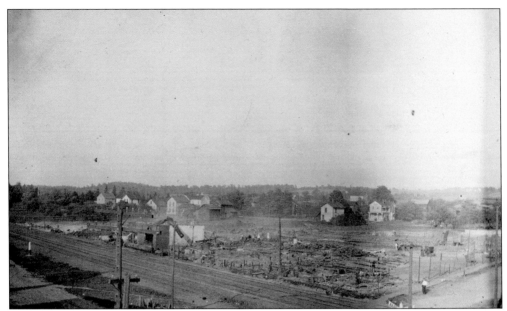

The Erie Preserving Company had been closed for about two years at the time of the fire. It was sold for $60,000 at a receivers' sale just a few days before the fire that completely destroyed the plant. The North Collins plant was extensive, covering several acres. It had included a large quantity of canning and other machinery, reportedly purchased for approximately $200,000.

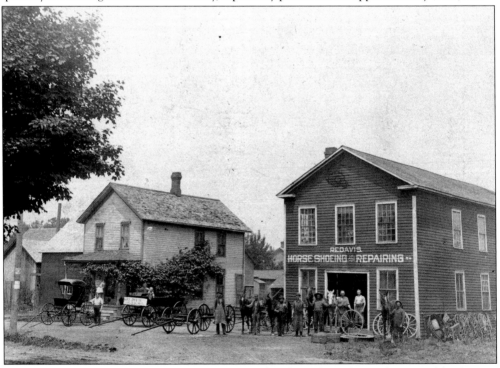

The blacksmithing business of R.E. Davis is said to have been located on Kimble Avenue c. 1880. He also shod horses and made metal repairs. From the looks of all the wheels across the front, he was also into wagon repairs.

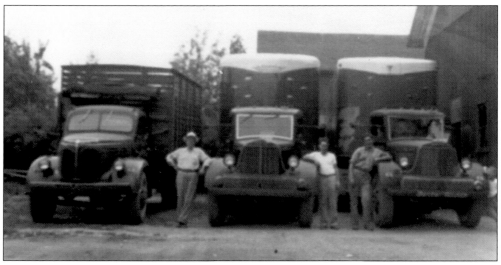

These trucks belonged to the business of Mose Cross, produce broker. His business was located at the southeast corner of Kimble Avenue and Elm Street c. 1925. The home at this location is still owned by a member of the Cross family.

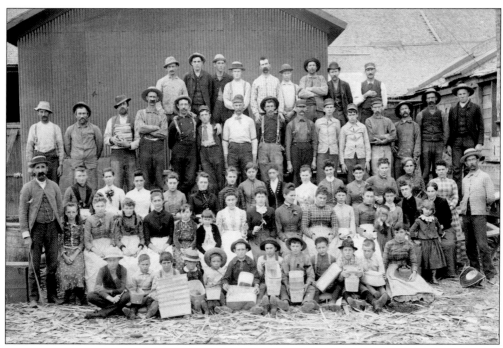

The North Collins Basket Factory, owned by Sherman & Brown, opened in 1887, with its own dryer for seasoning basket materials. From the dressy clothing on some of the children and adults, it seems likely this was a company picnic or gathering of some sort in 1890. Note the various size baskets that the company produced in large quantities. They were used mostly for produce.

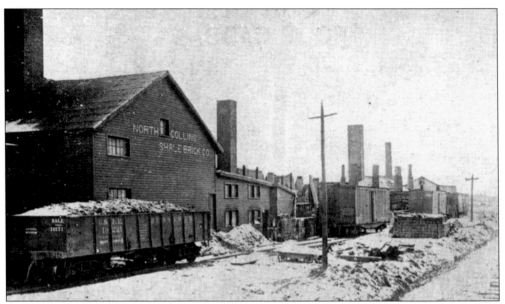

The Shale Brick Company in the village of North Collins operated from the 1880s to the early 1900s. Many of the local brick buildings were constructed using bricks made right in town. Until recent years, abandoned bricks could be found washed downhill along the railroad tracks in the southern portion of the village.

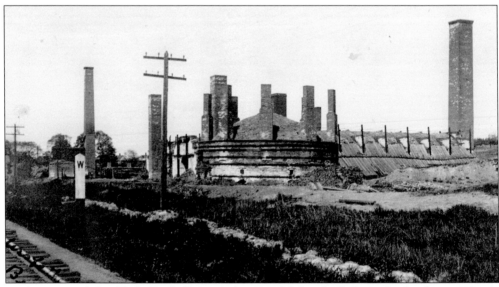

In this view of the Shale Brick Factory, the round kilns for baking the bricks are plainly visible in the foreground. The factory was built on the area now known as the lagoons to some residents. Bricks were made here from the stiff mud process. A large grinder crushed shale to coarse powder. The pug mill formed and shaped the stiff mud before a brick cutter sliced brick shapes. The bricks were taken to a drying room to dehydrate before being fired in the kiln. Bricks coming from the kiln were ready to use or ship.

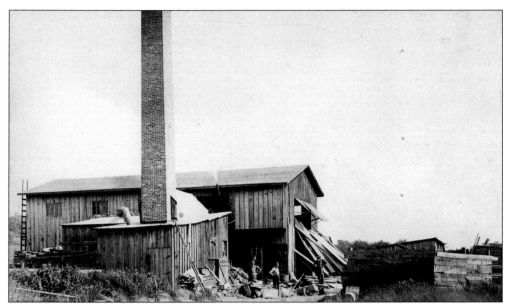

The Falk Lumber Mill was operating just off Mill Street *c. 1909*. The size of the mill and the lumber being produced at this time can be judged by the relationship to the three men standing at the end of the mill near the open doors. Mill Street was so named because by 1880 there were three mills in the same general area off the end of the street along the railroad tracks. This mill is very likely one of those mills. The name of the street was changed at an unspecified date to Kimble Avenue.

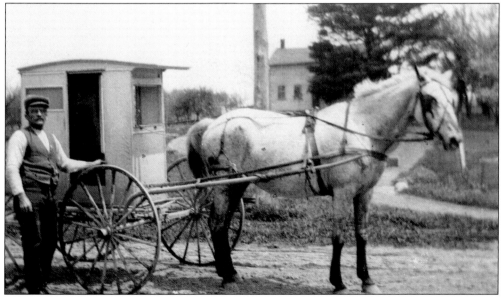

There were no formal mail routes in North Collins until after the War of 1812. From 1825 to 1874, the post office was listed as Collins, and mail was carried in a covered carriage twice a week and by railroad between Buffalo and Fredonia with stops along the way. Around 1880, August Pluntz carried the mail from North Collins to Shirley to Langford by dogcart. Mailman Elmer Whaley, pictured here in front of his home on Gowanda Road, covered Route 1 in North Collins for many years with his horses and mail cart no matter the weather. He retired in 1930.

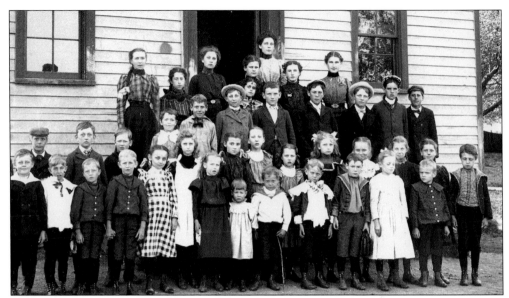

This school, shown c. 1890, is believed to be the second elementary school built in the village of North Collins. It is believed that there were two classrooms in the building, a fact supported by the two teachers in this photograph. The school was located immediately behind another school that was built in 1898. The 1898 school served as an elementary and high school until it burned in 1936.

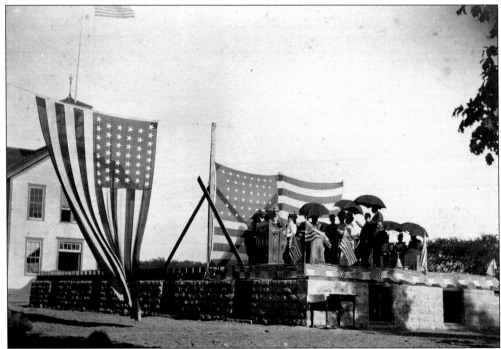

This photograph shows the dedication ceremonies for the new high school built in 1898 in North Collins. It combined the primary grades with the high school in one building. The foundation had already been completed, and presumably the cornerstone was laid following speeches by officials.

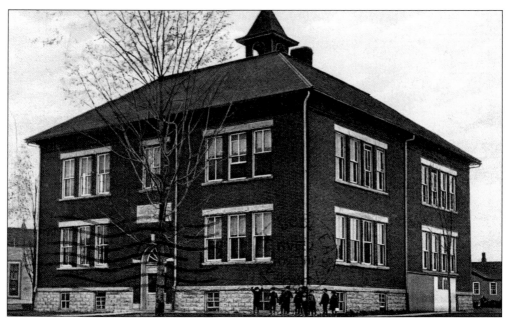

This two-story brick building served both elementary and high school students in North Collins when it was built in 1898. An addition was added in 1914 to provide four more classrooms. It continued to serve village elementary students and all town high school students until it burned on April 1, 1935, leaving only a bent fire escape. Principals at the school were A.C. Miller (1899–1901), W.B. Blaisdell (1901–1904), E.D. Ormsby (1904–1911), F.N. Zurbrick (1911–1917), Fred Schultz (1917–1918), F.N. Zurbrick (1918–1925), W.C. Jones (1925–1927), C.T. Sears (1927–1934), and W.F. Phelan (1934–1935).

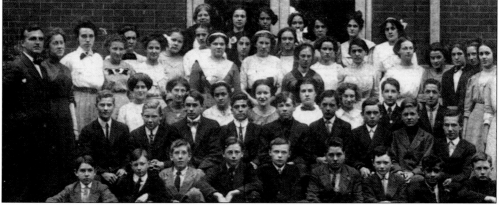

The pupils of all four years at North Collins High School pose in 1913. They are, from left to right, as follows: (first row) J. Lawton, L. Hill, A. Varney, W. Stuhlmiller, N. Parker, E.D. Brown, J. Lawton, W. Eppolito, and D. Gaylord; (second row) M. Warner, G. Macklin, L. Lawton, F. Valone, W. Tucker, L. Parker, H. Taft, B. Warner, and C. Taft; (third row) A. Congdon, E. Warner, M. Brown, H. Shefflin, M. Taylor, E. Lawton, C. Brown, and A. Thomas; (fourth row) principal F. Zurbrick, teachers Miss Parks and Miss Wells, two unidentified persons, L. Boulger, E. Bowers, L. Smith, E. Clark, N. Denzel, E. Bartholomew, L. Conrad, L. Diodato, I. Sisson, M. Peters, one unidentified person, A. Morrell, R. Haake, two unidentified persons, and M. Devoll; (fifth row) E. Taft, one unidentified person, C. Ticknor, L. Sisson, E. Haake, M. Ashdown, and L. Haake.

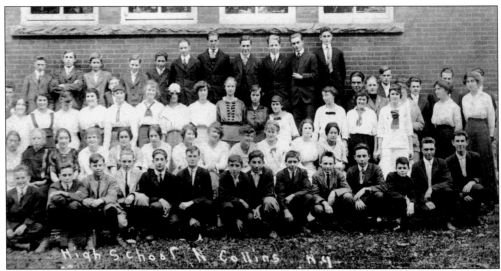

The eighth grade at North Collins School proudly poses beside their North Collins School in the village in 1915. Their teachers were Miss Park, Mrs. Graham, Miss Wells, and Professor Zurbrick.

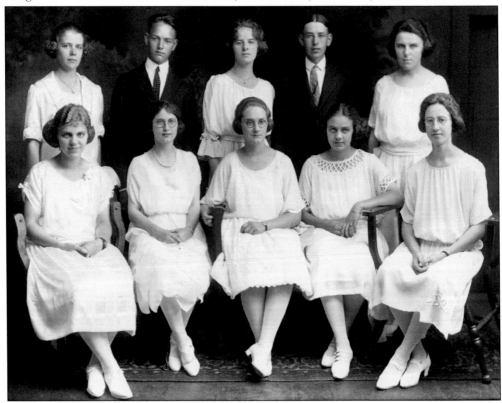

This picture shows the North Collins High School Class of 1922. They are, from left to right, as follows: (front row) two unidentified students, Ann Clark (later Mrs. Clayton Taylor), Josephine Taylor, and Monita Collard; (back row) one unidentified student, Harmon Taylor, one unidentified student, Loran Avery, and one unidentified student. Other members of the class were Dorothea Severson, Lucy Wightman, Lucille Riefel, Alberta Congdon, and Ella Long.

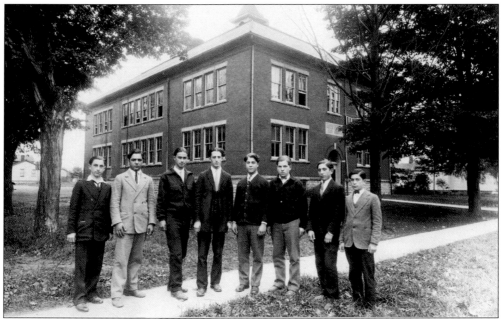

This picture of the 1898 high school with addition was taken *c.* 1930 at the corner of School and Main Streets. The young men shown are, from left to right, Paul Viggiano, Pete Magavero, Joe DeCarlo, Herman George, Frank Valone, Tony Mullay, Tony Elardo, and Frank Cocca. The building behind them burned in 1935.

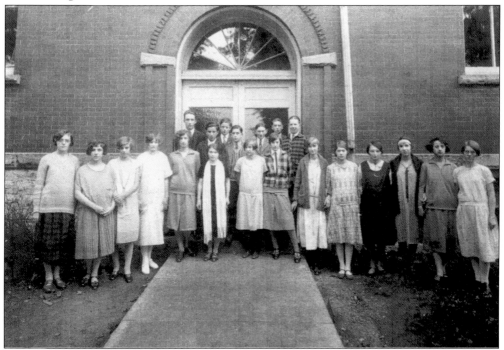

The faculty of North Collins High School poses *c.* 1925 outside the main entrance to the 1898 building. The last names of some of those shown are Jones, Warner, Gressman, Skuse, Cole, Gen, lly, Gier, Rehm, Bryfogle, Phillips, and Stearns.

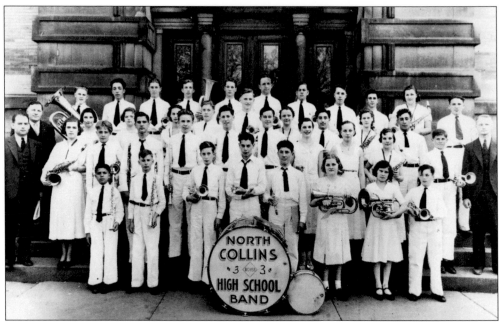

The very first North Collins High School Band, 1933, poses with its director, John Surra, and school board member Stanley Sobocinski (both on the left). Band members are, from left to right, as follows: (front row) Fred Loicano, Evans Mitchell, Robert Schasel, Victor Diodato, Frank Compisi, Christine Ahlers, Anna Martin, and Jerry Privatera; (middle row) Genevieve Rupp, one unidentified student, Michael LiVecche, Elsworth Rupp, Elton Wheelock, Glen Tarbox, Harland Rupp, Joe Macaluso, Esther Hammond, Ellen Gale, Betty Coon, Jim Alessi, Frank Martin, and Bob Sears; (back row) Louis Thiel, one unidentified student, Earl "Stoney" Lawton, Rexford Burnham, Carlton Hunter, Jim Briggs, one unidentified student, ? Dole, Charles Anzalone, Dorothy Ahlers, and Don Wagner.

When the cornerstone, dated 1936, containing a time capsule was laid in June 1936, more than 300 people attended the ceremonies. The school was constructed at a total cost of $217,000 and was opened for the second semester of the 1936–1937 school year. For the first time, there was a combination auditorium-gymnasium, locker rooms with showers, a manual training shop, a home economics room, a science lab, and library.

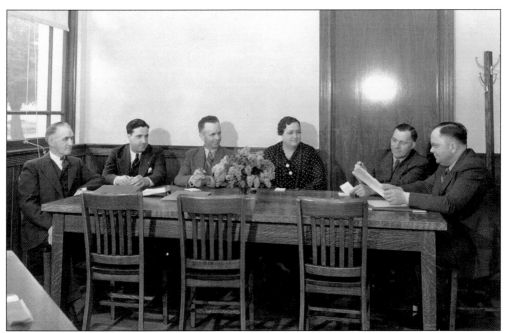

The North Collins District School Board in 1936 oversaw the building of the new North Collins School. The new school replaced a brick structure that had burned on April 1, 1935. It housed grades 1 through 12 on two floors and included a gymnasium-auditorium. The board members are, from left to right, Elmber O. Stearns, Charles D. Ognibene (clerk-treasurer), Herman H. Taft, Mona Ahlers, Stanley S. Sobocinski, and Clifford E. Bolton (president).

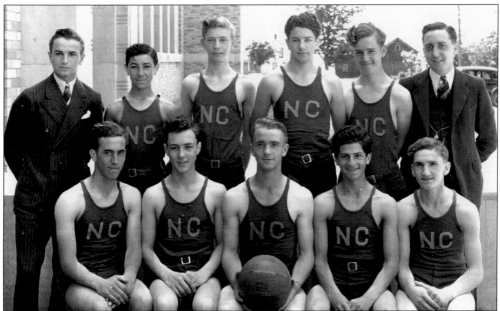

In 1936, North Collins High School fielded a basketball team, pictured here. From left to right are the following: (front row) Ray DiPasquale, Bob Thiel, Harold Robinson, Mike George, and Ed Orzelski; (back row) Al Musacchio, Frank Catalano, William Neubeck, John Romans, Lambert Graham, and George Wolfe.

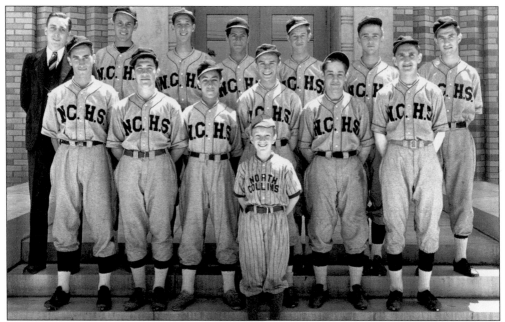

In 1936, North Collins High School also fielded the baseball team. Members of the team are, from left to right, as follows: (front row) Ray DePasquale, Frank Compisi, Frank Catalano, Al Musacchio, batboy Dennis Pollutro, and two unidentified players; (back row) Bob Korthals, Fran Johengen, ? George, Leroy Long, Harold Robinson, and Jim Geiger.

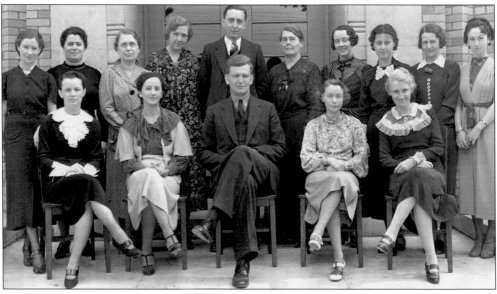

The North Collins High School faculty poses in 1936 in front of the school doors. From left to right are the following: (front row) Faith Morgan (senior homeroom), Sarah M. LaDuca (fourth grade), William F. Phelan (principal), Janet S. Cohen (music), and Isabelle Warner (junior homeroom); (back row) Charlotte Bicheler (seventh grade), Virginia Boardway (sixth grade), Nellie Barney, Mae Gier (freshman homeroom), George Wolfe (sophomore homeroom), Mae C. Rehm (eighth grade), Mabel Stearns (fifth grade), Ruth Phillipbar (first grade), Charlotte Sobetezer (second grade), and Gertrude Himmert (third grade).

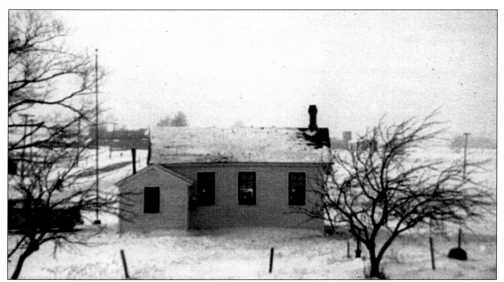

This snow-covered building is North Collins Schoolhouse No. 2, at the intersection of Genesee and New Oregon Roads, c. 1950. The building was constructed at a time when outhouses were built outdoors. The small wing on the left side was the cloakroom and bathroom addition. This school closed in 1950, when North Collins Central School District was formed.

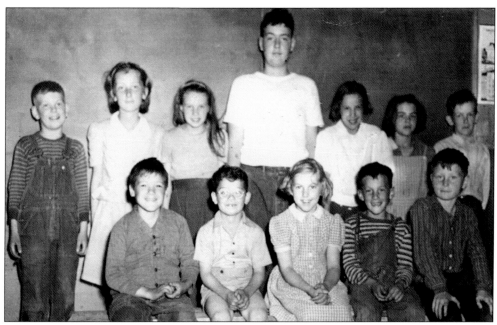

This 1940 class at North Collins Schoolhouse No. 2 was made up of students of the usual assortment of ages. Shown are, from left to right, the following: (front row) Martin Niefergold, David Rampino, Marjorie Wittmeyer, Jack Hartman, and Raymond Koningisor; (back row) Robert Wittmeyer, Jane Decker, Irma Miller, Harold "Bud" Brooks Jr., Dorothy Niefergold, Serena Hartman, and Andy Winegier. Absent was Margaret Niefergold.

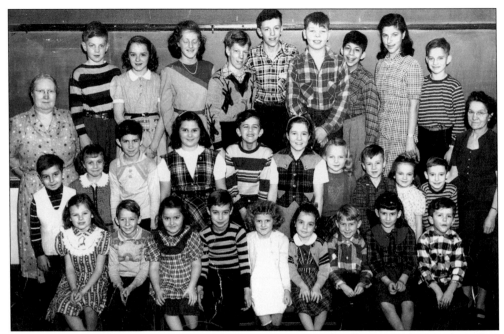

These c. 1950 students attend the two-room Brant No. 3 Schoolhouse in the North Collins School District. The school, located on the northeast corner of Mile Strip and Mile Block Roads, has been remodeled into a residence. Pictured are, from left to right, the following: (front row) one unidentified student, Eugene Ring, Marie DeCarlo, Paul Renaldo, Donna DeCarlo, Madelyn Conti, Ronnie Ring, and two unidentified students; (middle row) two unidentified students, Edward Ring, Rosalie Conti, one unidentified student, Patricia Bowman, Sharon Luce, two unidentified students, and Daniel Renaldo; (back row) ? Lomax, Anthony Renaldo, Dorothy Alff, Catherine Renaldo, Neil Bowman, one unidentified student, George Spunt, Francis ?, Marcella French, one unidentified student, and Eva Leiker.

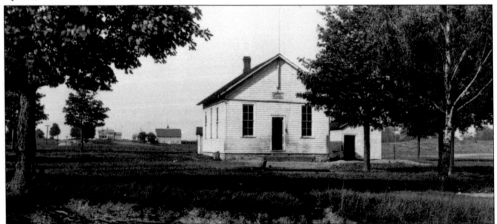

Schoolhouse No. 7 is located near the intersection of Shirley and Quaker Roads. Its earliest known school board minutes date from October 1835, when Lemuel M. White, Stephen L. Tucker, and David White were the trustees; James H. Kellogg was moderator; and Hugh Webster was clerk. Early local taxes to maintain the building ranged from around $5 (total, for books and building maintenance) per year plus firewood, which was brought by students. Average attendance in the mid-1800s was 10 students.

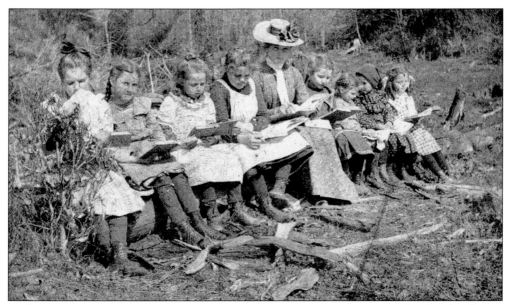

In this picture, probably taken in the late 1800s, the teacher at Shirley School, Schoolhouse No. 8, takes some of her students outdoors to work on their slates. The minute book of the school shows that it opened in 1835. It operated on "public monies" and a local tax on "those who are able to pay" averaging $5 to $8 per year in the mid-1800s. The numbers on some schools in the North Collins area seem to have changed in 1852 at the time North Collins separated from the town of Collins, but the Shirley School remained No. 8.

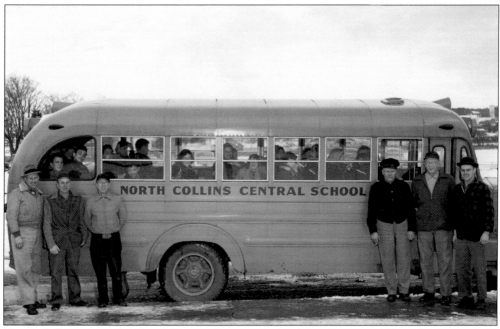

North Collins Central School District began its school bus fleet in 1955 with the purchase of this bus. Drivers pictured here are, from left to right, Walter Wittmeyer, R. Koningisor, Emerson Lawton, William Schmitz, Rufus Roth, and Nelson Wittmeyer. Nelson Wittmeyer remained on the squad for more than a half-century.

In 1955, North Collins High School presented *Father Knows Best*. The performers are, from left to right, as follows: (front row, seated) Joseph Rinaldo, Dianne Brooker, David Taylor, Margaret Britting, Donald Taylor, and Charlotte George; (back row, standing) Sharon Lietz, Daniel Vacco, Geraldine Eppolito, Betty Dillingham, Jeanette Hamman, Sam Pittro, David Hammond, Sharon Stevens, Phyllis Gruppo, Ben Munson, David Lawton, Margaret Bantle.

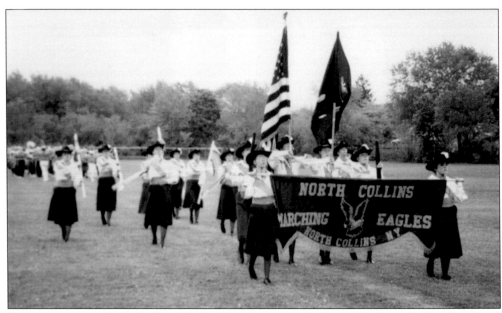

For many years, North Collins High School was proud of its Marching Eagles Band and Colorguard. They competed at top tournaments and almost always came away with top trophies. This *c.* 1993 picture appears to be the year the band used *Phantom of the Opera* as their theme, with the masked phantom himself appearing near the end of his theme music. The marching band was often accompanied by their mascot—the marching eagle.

The third annual Drive Your Tractor to School Day at North Collins High School was very successful. There were a total of 25 tractors on May 31, 2002. The oldest tractor was a 1940 Farmall H, driven by Jeremy Wittmeyer. There was a three-way tie this year for newest tractor. They were an MX220 driven by Faron Reding, a Ford 8970 driven by Jeff Schmitz, and the 2001 Case IH MX240 driven by Matt Hoffman. The dubious distinction of loudest tractor was won by the Super 99 Oliver driven by Westin Blidy, organizer of the event for the past three years.

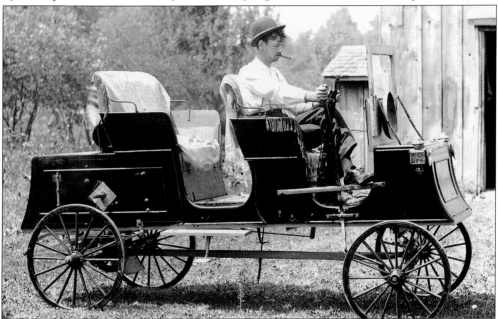

Roscoe Allen had one of the first horseless carriages in North Collins. He made this vehicle himself c. 1908 after seeing one in another town. He used his buggy (he no longer had a horse), an old motor, and parts from a manure spreader and from a grain grinder to make the power source. It had one gear—fast forward. Roscoe himself described beginning a ride as being "like a rocket taking off." The iron-rimmed, cut-down buggy wheels threw a shower of sparks whenever he started driving.

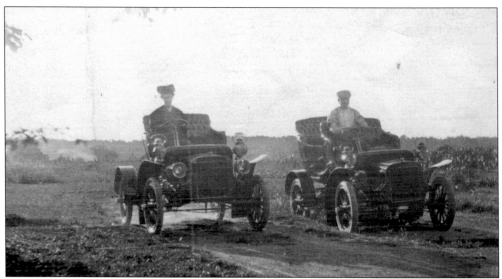

Grace Butler and John Rupp enjoy a fine day for a ride in the countryside. They were among the first in town to own a horseless carriage and enjoyed theirs as much as possible. This picture was taken shortly after the vehicles arrived in 1908.

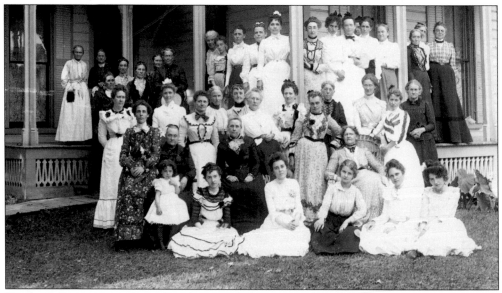

North Collins women formed a chapter of the National Political Equality Club in 1890, meeting twice a month at their homes to discuss local through national politics and work on projects such as making aprons for the National Bazaar in Washington in 1900. This picture was taken at a joint meeting of the North Collins and Lawtons Political Equality Clubs. Shown are, from left to right, the following: (first row) Sis McMahon, Ethel Smith Lawton, Mildred Knowles Schambacker, one unidentified member, and Rachel Brimmer; (second row) Hettie Denzel, Nellie Denzel Coon, Mrs. Caskey, Mrs. McAlister Smith, Mrs. Knowles, and Mrs. W.P. Sherman; (third row) Mrs. W. Bolton, Lucy White, Tell Hussey, Julia Haberer, Amy Kirby, Allie Butler, and Emma Dean Schley; (fourth row, standing) seven unidentified members, Edna Sherman Kelly, Alice Sherman, Lucy Charles, Neva Sherman White, one unidentified member, Emily Parker, and eight unidentified members.

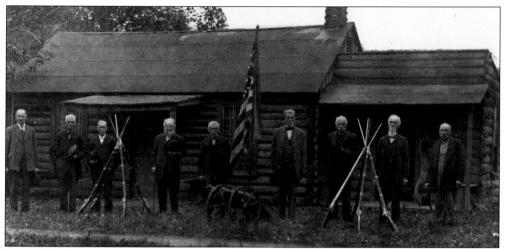

The S.C. Noyes Post No. 220, Grand Army of the Republic (GAR), in North Collins was formed on June 20, 1881, in Sherman Hall with 16 charter members; it later grew to 74 members. A log meetinghouse was built on Main Street in 1888 using logs donated by veterans. In 1920, the cabin was moved from Main Street to Sherman Avenue. In 1923, the two surviving members turned over the cabin and its contents to the Women's Relief Corps. The building deteriorated rapidly and no longer exists.

This GAR encampment by members of S.C. Noyes Post No. 220 was probably held at Hemlock Hall and may have been sponsored by the S.C. Noyes Post for other GAR groups to participate. Hemlock Hall was located in the town of Brant. This event was probably held c. 1890.

The Queen Esther Circle was a benevolent organization of the Methodist Episcopal church. The women were successful fundraisers, but little else is known about the group. Members include, from left to right, "Bunny" Hunter, one unidentified member, ? Ruhling, one unidentified member, Florence Creed, Mabel Kirby, Gertrude Burnham, one unidentified member, Minnie Falk, one unidentified member, Edith Twichell, and ? Storm.

The east side of Main Street c. 1953 included homes on the left, the Masonic Temple, and a wooden apartment building owned by Mrs. Cole. By the time this picture was taken, the Jim Alessi building fire had just been brought under control. The site of the apartment house is now a parking lot.

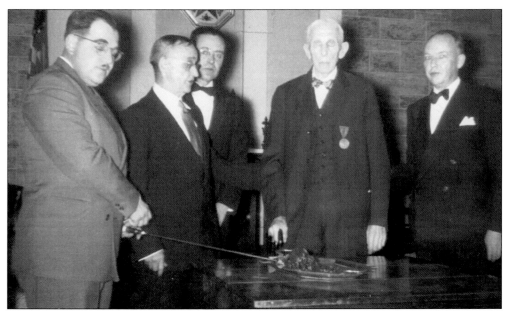

Members of the Free and Accepted Masons lodge celebrated the final payment on their mortgage by holding a symbolic mortgage burning on December 15, 1940. The location, their temple, was built in 1921. From left to right are W.A. Mullay, Rev. Charles W. Master, Merritt Hammond, R.W. Harrison Parker, and Art Havens.

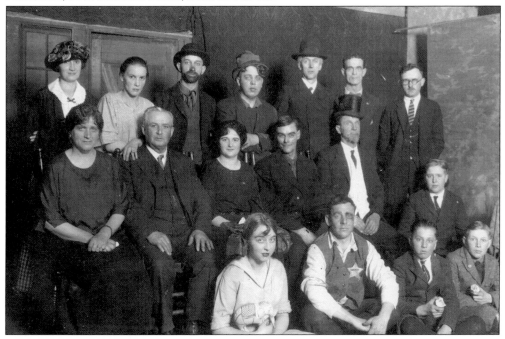

This group performed *The Country Squire* as a benefit for North Collins Rebekas on March 13, 1924. Pictured are, from left to right, the following: (front row) Frances VanTassel, George North, Jurden Mattice, and Walter VanTassel; (middle row) Hattie Heath, Frank Heath, Anna Mae Heath, John Brauner, Herb Congdon, and one unidentified boy; (back row) Isabel Warner, Esther Riefel, Herb Johengen, LeRoy Carlson, M.P. VanTassel, Ed Conrad, and Ancel Riefel.

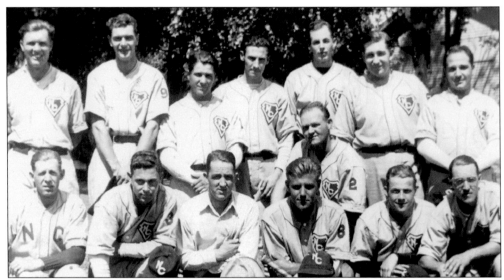

In 1936, the North Collins baseball team won the Lake Shore League Championship. The team members are, from left to right, as follows: (front row) coach Ken Linsler, third baseman Len Geiger, manager Wallace "Turtle" Conrad, catcher Chuck Tarbox, right pitcher "Beanie" Bowers, right fielder Bill Worth, and second baseman Don Conrad; (back row) pitcher, infielder, and outfielder Fred Miller, center fielder Ed Karlinski, outfielder Frank Valone, right pitcher and shortstop Cy Geiger, first baseman Bill Stickney, left pitcher Clayton Herman, and left fielder Sam Compisi.

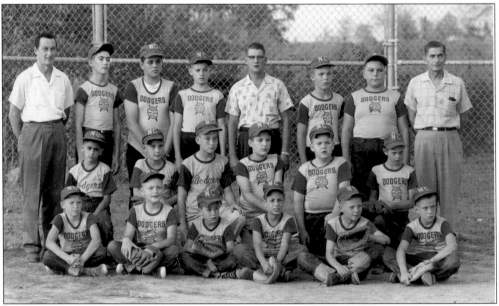

This team won the league championship in 1960 under manager Paul Bley. From left to right are the following: (front row) Daniel Ortel, Robert Olds, Ronnie Warnes, "Red" Mussachio, Kenny Lawton, and Steve Sietler; (middle row) Larry Turnbull, Mike Hosul, Ron Burgess, Phil Ricano, Jeffrey Pridgeon, and Melvin Bley; (back row) Bob Ortel, Tony Pridgeon, Jim Fazzolari, Tom Husol, Paul Bley, Bob Clark, Angelo Nasca, and Omar Olds. Bob Ortel and Omar Olds were the assistant managers.

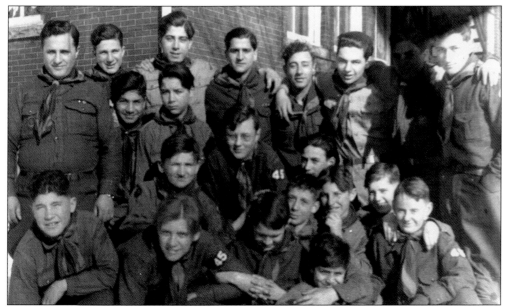

Boy Scouts have been active in North Collins since the early 1900s. Scouts in 1932 are, from left to right, as follows: (first row) Frank Compisi, Alton Wheelock, D. Hibbard, Fred Loicano, and John Collard; (second row) Ed Orzelski, F. Johengen, A. Volo, G. Andolino, and L. Graham; (third row) Joe Alessi, Carmen Prime, and C. Catalano; (fourth row) Anthony Pero, M. Agliata, M. LeVicche, J. Alessi, Wesley Plenz, Vito Pero, and J. Thiel. It was during this period that there was a Boy Scout camp on the Boardway Farm in Lawtons.

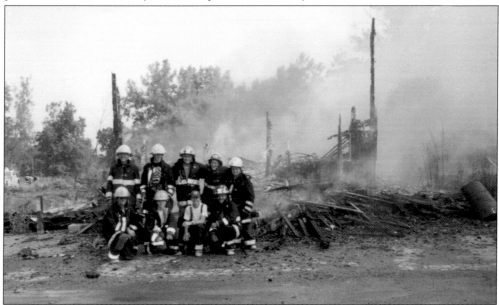

The Emergency Explorer Scouts in North Collins train to be future firefighters and emergency response personnel. While they do not work a live fire, they help the firemen in any way requested at the scene. Using playground equipment, they learn necessary skills such as climbing, passing through confined spaces, hauling gear up and down using ropes, and connecting and using a fire hose. They are pictured in 2001 at the practice burn in Lawtons.

Celebrating the North Collins centennial in 1953, several North Colins businesses entered floats in the parade. This float, built by J.N. Schreiner & Son Memorials, passes the Johengen Hardware Company at the southeast corner of Main Street and Sherman Avenue. Neither business exists today.

Lawtons Home Bureau participated in the parade celebrating the centennial of North Collins in 1953. The float made by club members is shown on Main Street passing the Johengen Hardware Company. The organization is no longer active as Home Bureau.

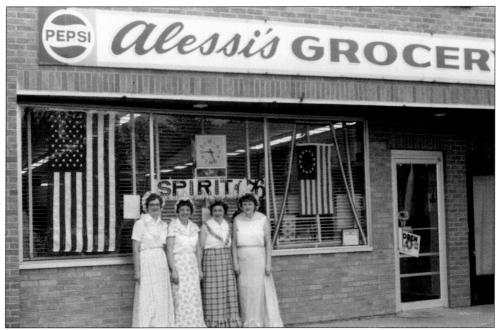

In 1953, when the town of North Collins centennial was celebrated, "the DiPiazza girls"—Josephine Alessi, and Pauline, Grace, and Jean DiPiazza—dressed for the celebration and posed in front of the store. The girls had all worked at the store for many years. Alessi often joked that when he married Josephine, he got the whole family as employees.

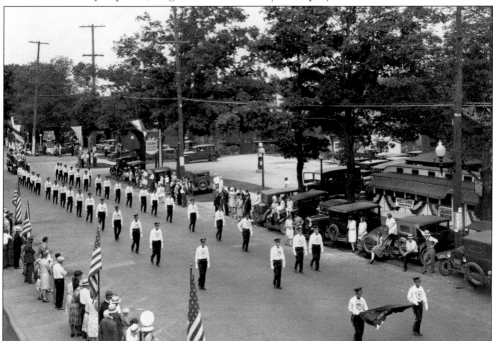

North Collins firemen participated in the Southwestern Association of Volunteer Firemen's 21st Convention at Falconer, New York, in August 1929. The men represented both Kimble Hose and Kimble Hook & Ladder.

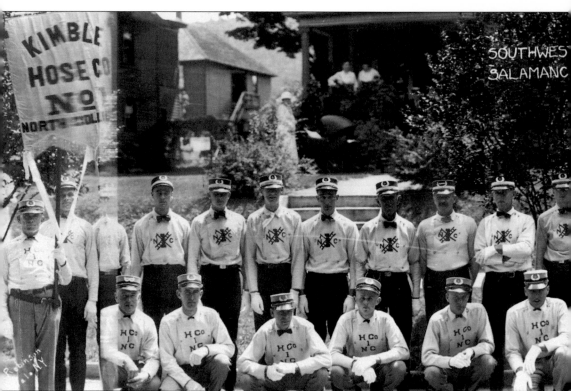

Although North Collins Fire Protection was first organized in 1889, Mayor Albert Kimble reorganized it in 1915 into the Kimble Hose Company and Kimble Hook & Ladder Company, with a small fire hall on Main Street. Pictured in August 1921 are, from left to right, the following: (front row) C. Falk, H. Willett, L. Lindow, B. Winter, J. Congdon, C. Andolino, K. Linsler, S. Manuel, C. Bunnell, W. Hunter, F. Baird, C. Bunnell, H. Ahlers, H. Hibbard,

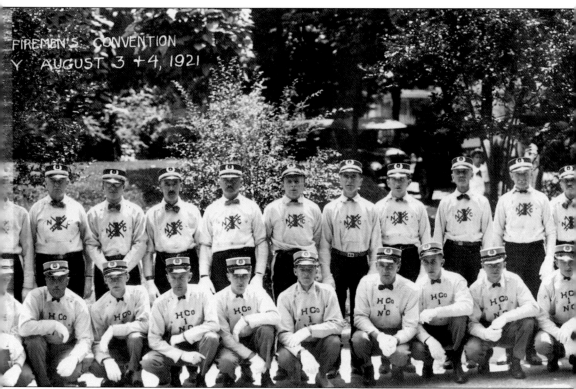

F. Pittro, and W. Conrad; (back row) A. Cocoa, L. Briggs, N. Burnside, ? Schreiner, M. Yager, R. Allen, E. Smith, J. Cross, J. Alvers, H. Graham, O. Gaylord, M. VanTassel, H. Butler, S. Sobocinski, E. Ruhling, C. Brown, G. North, H. Lawton, D. Dickman, S. Willett, G. Southwick, and A Kimble.

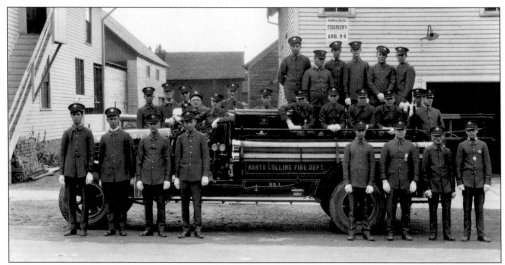

In 1926, the Kimble Hose–North Collins Volunteer Fire Company purchased this new pumper and posed with it in front of the fire hall on Main Street. The members known to be in the photograph are Wilson Hunter, Ed Conrad, Charles Andolina, Nelson Burnside, William Dash, Ned Andolina, Joe Valone, Rodney Russell, Hoyt Hibbard, George Dash, Ken Linsler, Chief John Reithand, driver Emerson Lawton, Frank Pittro, John Rupp, Frank Valone, John Esposto, Fenton Dillingham, Anthony Valone, Stafford Russell, Stanley Johengen, William Boulger, Herb Johengen, Frank Allen, Mike Pittro, George Southwick, and Frank Lorenz.

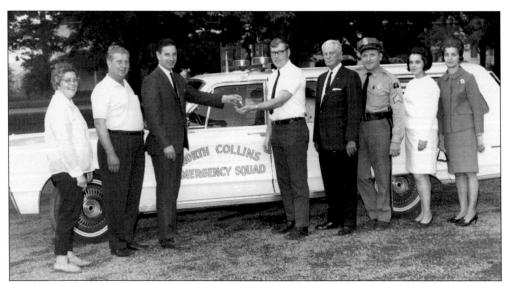

Ambulance service in the town of North Collins began on June 1, 1969, when the North Collins Emergency Squad began service. The all-volunteer squad began with 51 charter members and has now become a paramedic unit. Pictured in May 1969 with the squad's first ambulance are, from left to right, Frances Pisa (roster lieutenant); Robert Kibler (supply lieutenant); Marion J. Fricano (supply lieutenant), supervisor of the town of North Collins; David Otteni (director of operations); Wilson Hunter (president); Donald Myers (vice president); Ceil DeMeo (secretary); and Sue Cocca (treasurer).

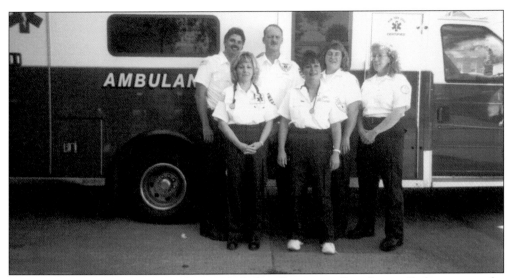

As a full-fledged paramedic unit, the North Collins Emergency Squad was called to serve at the triage station at the World Trade Center after the September 11 terrorist attacks. They were the only western New York unit called to serve two shifts—September 17–18 and September 22–23. The crew, pictured with the newest ambulance, includes, from left to right, (front row) Denise Perry and Diana DeCarlo; (back row) Jeff Singleton, Michael Perry, Kathy Mallaber, and Dorothy Judson. Also serving in New York City but not pictured are Phillip Tremblay and Eric Wiesedel.

The southern Erie County 4-H cookie depot was staffed for nearly 40 years by leaders from Lawtons Progressors 4-H Club in North Collins. It disbursed about 500 cases of cookies among about a dozen area clubs annually. This cookie depot at the Neil Bowman residence in 1992 found club leaders stacking cases of cookies from the delivery semi. Shown are, from left to right, Neil Bowman, Sue Kehr, Alice Ayers, club leader Marion Wittmeyer, and Pete Kehr. Previous cookie depots were at the homes of Nelson Wittmeyer and Donald Lawton. The county cookie depot is now at Erie County Fairgrounds.

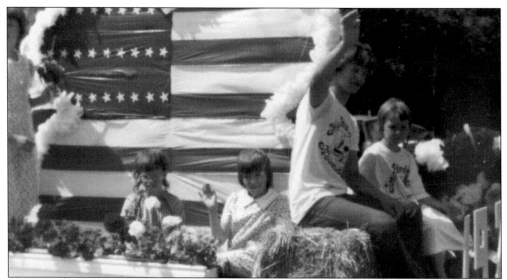

Lawtons Progressors 4-H Club got into the patriotic spirit with this national bicentennial float bearing a flag-colored 4-H clover. Riding the float are, from left to right, Barbara Hodgson, Deborah Bowman, Candice Bowman, Wayne Peters, and Chris Purdy. The club used this float in the North Collins Fourth of July parade as well as the Pumpkin Festival Parade that year.

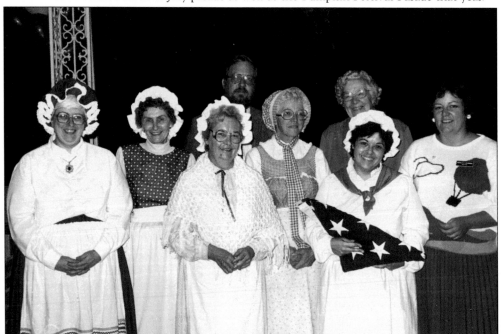

North Collins residents celebrated the bicentennial of the United States in 1976 along with the rest of the nation. There was a community balloon launch to open the festivities, a parade, and other activities, including the Community Tea served at North Collins Memorial Library, at which this picture was taken. The U.S. Bicentennial Committee of North Collins was chaired by Brenda Bauer (holding flag). Other members pictured are Georgianne Bowman, Nancy Bottoni, Joyce Loretto, Thomas Mudra, Patricia Ricotta, historian Grace Korthals, and library director Michelle Kujawinski.

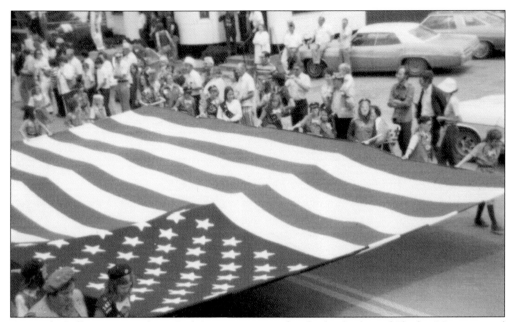

A North Collins Intermediate Girl Scouts troop under the leadership of Shirley Noto assisted their mothers in sewing this huge flag especially for the national bicentennial celebration. They ran poles beneath it to be sure it never touched the ground. They joined forces with a Brownie troop to carry it in the Fourth of July parade down Main Street.

In 1993, Friends of the North Collins Library were in full swing raising funds for construction of a new, larger library. A lawn furniture raffle on the library porch was the order of the day along with a book sale by the library. From left to right are Brenda Bauer (back to camera), Nancy Bottoni, and Carol Riefel, members of Friends of the Library. In the back are Vincent George and Thomas Mudra, library board members.

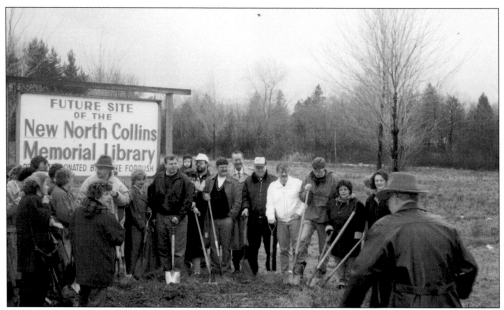

This is the first groundbreaking for the new library on School Street. The Women's Relief Corps received community help to renovate the carriage house of the Enos Hibbard estate on Main Street in 1921. Since then, a front door was added on the Vermont Street side with a roofed concrete porch area for children's summer programs.

Men and women from southern Erie County have always served their country in times of crisis. Shown at Camp Dix in 1956 are, from left to right, the following North Collins residents: (front row) Paul Bowman and Maynard Lawton; (back row) Chuck Schmitz, Dave Peters, and Fred Haier.

The veterans of the North Collins area are proud to have served their country. These members of the William F. Dils Veterans of Foreign Wars Post Colorguard from North Collins participate in the annual Strawberry Festival Parade on Fathers' Day 1993.

The North Collins Senior Citizens Club formed in 1972 and is still going strong. Many of the original members are pictured on this day trip to Belhurst Castle in Geneva, New York, in August 1985. The club has a busy schedule, with twice monthly meetings, spring-through-fall monthly day trips, a longer trip each fall, dinners for special holidays, an annual Chinese auction, annual picnic, food pantry collections, and other activities.

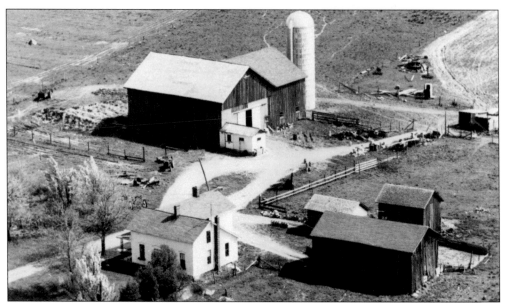

This aerial view of the Fred Miller dairy farm, at the southeast corner of Genesee and Jennings Roads, was taken in the summer of 1959. The farm was the homestead of Jacob Staffen, the only six-term supervisor of the town of North Collins in the 1800s. The house and barn date from the mid-1800s, and the farm's physical composition had changed little except for electrification and modern health requirements. Fred Miller was Staffen's grandson.

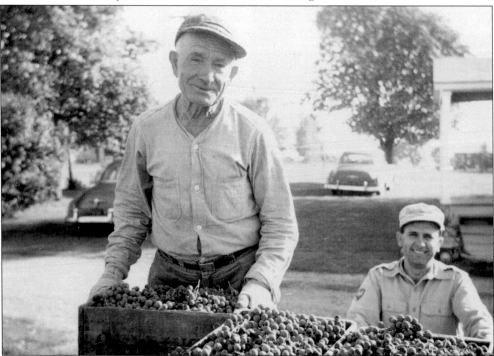

This bountiful harvest of grapes dates from 1960, when the grapes had to be picked by hand and the boxes stacked on the truck by hand. Pictured on the Spicola Farm are Joseph Spicola and his son Sebastian.

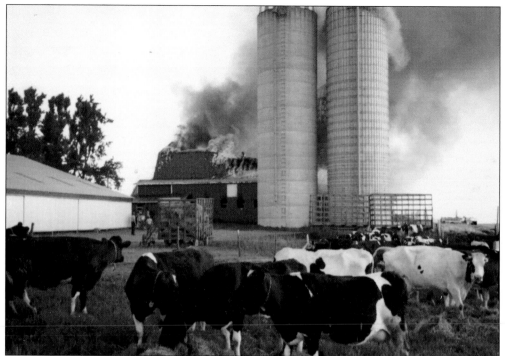

On July 4, 1980, the Richmond family lost their large dairy barn to fire. When the fire was discovered, half the morning milking had already been done, so many of the cows were not in the barn. However, seven heifers and the barn were lost. A new barn was built as quickly as possible in the same spot. The business is now run by another generation of Richmonds, brothers Charles and John, as the Richmond Farm Dairy.

Lynn Bowman Sr. mans Bowman Farms vegetable and produce stand on Route 62 between Milestrip and Shirley Roads in North Collins. Potatoes, tomatoes, and corn appear to have been in season c. 1960, but the stand also sold peas, strawberries, raspberries, string beans, cabbage, squash, and pumpkins. Bowman Farms Inc. later expanded to include citrus groves in Florida and, after discontinuing potato production, expanded grape production in the town of Brant. A new, larger stand replaced this one some years ago.

In 1914, Edward and Nora Geiger purchased the farm at the end of Gurney Avenue in the village of North Collins. Known as E.P. Geiger & Sons, the farm sold vegetables and fruits. It has continued down through family hands and, in 1983, Edward and Millie Awald purchased the farm. Awald Farms is now a self-pick and ready-picked farm specializing in strawberries, raspberries, and blueberries, as well as all sizes of pumpkins. Wesley Awald and father Edward show the farm's sign on Route 62.

The official celebration of the North Collins sesquicentennial opened in January 2002 with the placement of the anniversary banner on road signs at the north and south entrances to town. Many people helped plan events throughout the year, including, from left to right, the following: (front row) Georgianne Bowman, Keith Dillingham, Judith Thomas, and Marie Compisi; (back row) Mary Ann Peterson, Rev. Derrick Yoder, chairperson Margaret Orrange, James Mardino, Sue Alessi, and Teresa DiPiazza. Absent are Ray and Marian Vanni and Corinne Leone. The celebration is "Looking to the Future, Rooted in the Past."